D0948420

MANNERISM IN ART, LITERATURE, AND MUSIC: A BIBLIOGRAPHY

MANNERISM IN ART, LITERATURE, AND MUSIC: A BIBLIOGRAPHY

Compiled by
Richard Studing
and
Elizabeth Kruz

TRINITY UNIVERSITY PRESS • SAN ANTONIO, TEXAS

Checklists in the Humanities
and Education: a Series

Harry B. Caldwell, Trinity University, General Editor

As a continuing effort, *Checklists in the Humanities and Education: a Series* endeavors to provide the student with essential bibliographical information on important scholarly subjects not readily available in composite form. The series emphasizes selection and limitation of both primary and secondary works, providing a practical research tool as a primary aim. For example, this volume brings together pertinent materials of twentieth-century criticism dealing with the development of Mannerism in art, literature, and music. Listed alphabetically, the entries serve as a convenient index to the critical literature on the subject. Likewise, subsequent volumes will remain selective, limited, and concise.

CONTENTS

INTRODUCTION

That no extensive bibliography or checklist on Mannerism in the arts has appeared is remarkable—especially since Mannerism is such an important historic link between the arts of the High Renaissance and Baroque. Despite the general agreement that Mannerism is an historic era in its own right, there is much argument concerning precisely how the term should be used in the arts. In his introduction to *The Meaning of Mannerism*, Franklin W. Robinson points out that Mannerism, as applied to the arts, needs more debate and clarification:

Some scholars maintain the term should be used only in referring to visual works of art, or even just to painting and prints, while others would apply it to all the arts and even to social phenomena. There is no question, then, that serious debate on mannerism is needed; this fact, in itself, would justify the present volume. . . . This book raises, implicitly and sometimes explicitly, a fundamental question: Is it possible—or desirable—to have valid insights and interpretations of an interdisciplinary nature?[1]

Based on the large body of works written on Mannerism, we would venture the answer to Robinson's question is yes. The purpose of this bibliography is to bring together the pertinent materials of twentieth-century criticism dealing with Mannerism in art, literature, and music.

Viewed collectively, the individual sections of this bibliography combine to present source materials on the development of Mannerism in the arts. Separately, each section provides a basis for the study of Mannerism in a particular discipline.

Mannerism is rooted in the term *maniera*, which can be traced to its sixteenth-century social definition akin to what we call "manners" today. Grace and elegance, important social traits of the Italian Renaissance as espoused by Castiglione in *The Courtier*, were incorporated into a conception of art by Giorgio Vasari (1511–1574), who equated *maniera* with artistic style. *Bella maniera* and *la maniera moderna* represented the highest achievement of expression in art, encompassing the ideals of ease, facility, and sophistication. Raphael's *St. Michael* and Michelangelo's *Ignudi* have been cited as examples of this expression.[2] Renaissance painting implied a certain abstraction from reality, which was considered a desirable quality. Only when this quality became intensified and exaggerated, as artists began to deviate drastically from the order of Renaissance art, did Vasari alter his meaning of *maniera* to explain this deviation as an affectation. Towards the end of the sixteenth century, the meaning of *maniera* changed from being a synonym for style to the pejorative term, "conscious stylization." By the seventeenth century, it had no redeeming features to its credit; for the theorist, Giovanni Bellori, considered *maniera* the artistic vice responsible for the ruin of Renaissance art. In 1792, Luigi Lanzi, the historian, was the first to connect the term with a particular group of Italian artists; therefore he is credited with the "invention" of Mannerism as used today to denote a stylistic period. Mannerist art was peculiar to Italy, with work done in other countries modeled on Italian sources. So from the sixteenth century on, we find *maniera*, *manierismo*, and *maniérisme* in dictionaries, encyclopedias, and histories of art, defining qualities attributed to works of the late Renaissance.

Although principally an Italian stylistic development, Mannerism includes major figures in all the arts from various countries. In the fine arts, the mannerist spirit is manifested in the late work of Michelangelo (specifically from the Laurentian Library on) and in the art of Rosso, Pontormo, Parmigianino, Tintoretto, Bronzino, and Breughel. From Italy, Mannerism spread to France, England, and other European art centers, culminating in the painting of El Greco. Also, the architecture of Giulio Romano and Andrea Palladio has been designated "mannered," as well as the sculpture of Giovanni da Bologna and Benvenuto Cellini. As a literary phenomenon, elements of this style are present in the ornamented and ingenious writings of Antonio de Guevara, John Lyly, Giambattista Marino, and Cervantes. Moreover, the prose of Montaigne,

the poetry of John Donne, and Shakespeare's *Hamlet* have been viewed in the mannerist tradition. In music, the foremost composers are Orlandus Lassus and Carlo Gesualdo, the Prince of Venosa. Lassus' dynamic compositions departed from the balance, order, and serenity of Josquin Des Prez and Palestrina. And, indeed, the emotional chromaticism and unusual harmonic effects of Gesualdo's music were extreme departures from the classical Renaissance style.

As a period and stylistic designation, Mannerism belongs primarily to art history. It refers to those works of art produced roughly between 1520–1600. Stylistically, it is a movement away from the classicism of the High Renaissance masters, most notably the ideal beauty of Correggio, Raphael, and the early works of Michelangelo. Unlike classical art, which is based on direct observation and refinement of visual perception, mannerist art is intellectual, placing great value on originality and imagination. Thus, emphasis was given to the achievement of sophisticated effects: exaggeration of perspective, form, and color and emotional extravagance. Also, the *contrapposto* and *figura serpentinata*, derived from Michelangelo, were overemphasized in sculpture and painting. A good example of this is seen in Giovanni da Bologna's *Rape of the Sabine Women* (1583). Artistic ingenuity and virtuosity often led artists to paint bizarre scenes and morbid pictures. Furthermore, some mannerists strained to produce the Neo-Platonic idea of *disegno interno*, the artist's ideal visualization of his subject as opposed to the real appearance of it. Historically, the art of this period was considered decadent, a mere juncture between Renaissance and Baroque. This negative connotation held until the twentieth century, when mannerist art began to be viewed as a singular style. Indeed, its intensity and unnatural beauty guaranteed its independence from the art of other eras.

Mannerism emerged as a legitimate era and style in art history in the post-World War I atmosphere of Expressionism in Germany. Max Dvořák and Walter Friedländer were responsible for this "revival" of Mannerism. Each possessed a different view of the subject, however, and these views were reflected in subsequent studies of Mannerism. In his essay, "Über Greco und den Manierismus" (1928), Dvořák discussed Mannerism in terms of the emotional content of the art works; he saw the style as a spiritual expression, using El Greco's paintings as the foremost example of his hypothesis. In contrast, Friedländer's approach was historical. Friedländer, in "Die Entstehung des antiklassischen Stiles in der italienischen Malerei um 1520" (1925), analyzed Mannerism in Italy and defined it as anticlassical from the viewpoint of style. These two pioneering studies sparked an interest in the art of Mannerism, and for several decades after the appearance of the Dvořák and Friedländer

essays, a vigorous exchange of ideas on the subject resulted in a number of books and articles yielding a wealth of information on the polemical topic.

A serious problem developed, however, when scholars sought to define Mannerism by adhering strictly to either Dvořák's or Friedländer's approach. Sydney J. Freedberg adopted the disciplined method of Friedländer in his study of Roman and Florentine painting of the Renaissance, while Gustav René Hocke chose to emphasize the emotional elements of Mannerism, which by the 1950s had been strongly influenced by Surrealism and stressed the fantastic over the purely spiritual traits. According to Henri Zerner, the opposing schools of mannerist theory did not prevent scholars from claiming to know exactly what the meaning of Mannerism was. But as the gap between the schools widened, it was evident that Mannerism was not harnessed, but rather an elusive phenomenon. As Henri Zerner observes, "There was, therefore, no longer any agreement about a core of works one could call mannerist, and the historiography of Mannerism arrived at a crisis."[3] This crisis must be acknowledged by anyone undertaking research on Mannerism. As an art style, it occurred during a very eventful historical era, and it cannot be restricted by narrow ideas or interpretations. Many authors have made sound contributions to the question of Mannerism, and they should be consulted at the start of any project involving this period.

The historical path followed by Mannerism in literature is short and narrow compared to that followed by art. There are no references to mannerist literature before the twentieth century. Max Dvořák's essay, considered earlier, is the first place we find mention of Mannerism in literature. Basically a concept of art history, it is only natural that Mannerism would have been introduced to literary criticism by an art historian, resulting in an immediate connection between the two disciplines. Generally, Dvořák transferred his theory on realism and spiritualism in mannerist art to literature. On the one hand, Shakespeare, Rabelais, and Grimmelshausen are mentioned, and on the other, Cervantes, St. Francis de Sales, and St. Theresa are considered major figures representing the two trends.[4] Dvořák's ideas on mannerist literature were broad, and though important, did not incite any real interest in literary Mannerism until the 1950s.

When the debate on literary Mannerism began, however, it was an active one which continues today. The premise of the argument was whether it represents a specific stylistic period or a continuous trend in literary history. The first to deal with the latter viewpoint was Ernst Robert Curtius. In *European Literature and the Latin Middle Ages* (1948 & 1953), Curtius generalized the idea of Mannerism in literature as a

style of affectation occurring repeatedly as an anticlassical literary force. Certain periods, he allowed, were dominated by mannerist tendencies; but one could not restrict the concept to sixteenth-century literature alone. This view became popular when adopted by Curtius' pupil, Gustav René Hocke, who also described Mannerism as the use of exaggeration during any given period. But unlike his teacher, Hocke saw this as a positive rather than a negative deviation from classicism. Indeed, for Hocke, the opposition of the classical and mannerist styles was "metaphysical," each in its own way revealing the "absolute."[5] Helmut Hatzfeld, the literary historian, took the position that Mannerism should be confined to a single period. In his writings on Spanish and French literature, Hatzfeld represented literary Mannerism as a transitional style between the Renaissance and Baroque. Although he agreed with Curtius that its characteristics made it a negative development, he assigned Mannerism to a specific historical period. Of the two basic approaches, the belief that Mannerism was an ongoing trend had more appeal; for it left open space for interpretation. As a result, research on the subject has been less cohesive than in art history.

Other scholars have contributed fine studies on literary Mannerism. Marcel Raymond has produced a great deal of research on the topic. He divides Mannerism into specific types and discusses these subdivisions in detail. Mannerism in English literature has been studied by Mario Praz in his essay, "Baroque in England." Roy Daniells has revealed a relationship between Mannerism and Milton in his article "Milton and Renaissance Art," and in his book *Milton, Mannerism and Baroque*. And Georg Weise has done comparative work in literature and art.

The history of research concerned with Mannerism in music is limited in comparison to that of art and literature. Much of the music of the sixteenth century was composed at the request of patrons. As in most commissioned works of art, the artist, writer, and composer desired to exhibit virtuosity. Some composers of this period, like the artists, reacted against the classically ordered style of the Renaissance. In music, the madrigal provided the main vehicle for this virtuoso expression of anticlassicism by a particular use of polyphony and by the juxtaposition of idealism and realism in the lyrics. This musical display resulted in "intellectual" works, to be comprehended and appreciated by an elite, sophisticated audience for whom they were created. *Musica reservata* is the term most commonly applied to this type of sixteenth-century composition, with Mannerism linked to it, described as a consciously affected, "stylish" style. Although parallels have been drawn and examples given showing the "mannered" elements of the sixteenth-century madrigal, the concept of Mannerism is still approached with caution by music historians. As

Don Harran remarks, "For some reason or other, the notion of a musical mannerism, though championed in a small body of scholarly writings[,] has failed to win a following."[6]

In 1927, Theodor Kroyer introduced Mannerism in music as an interim style between Renaissance and Baroque, and in 1934, Leo Schrade found the basis of musical Mannerism to be the reaction against the idealism and order of Renaissance music. From these beginnings, the research continued at a slow pace, leaving us with a smattering of essays on the subject. Most research on Mannerism questions whether or not the term is appropriate for music—with scholars generally not taking one side or the other. This stasis persisted until 1973, when Glenn E. Watkins energetically defined Mannerism as a distinct style in sixteenth-century music, citing the eccentric madrigals of Gesualdo as prominent examples. Watkins' *Gesualdo: The Man and His Music* devotes a chapter to the question of Mannerism in music, an excellent discussion. He leaves the reader with this point of view:

> It is doubtful that the period of Mannerism can any longer prudently be labelled a colourful intermission somewhere between the Renaissance and the Baroque, or considered the coda to a more prominent, more clearly defined age. . . . The enormous strides and import of the stylistic pursuits undertaken during this time were of such dimension that this era is destined to achieve an identity clearly distinguishable from that of the periods which preceded and followed it.[7]

This identity will undoubtedly surface as music historians deal more directly with Mannerism as a style in its own right. Furthermore, the compilers are confident that this bibliography will be a cadre for future studies of Mannerism in all the arts.

The bibliography is divided into five sections: Art, Exhibitions and Related Publications, Literature, Music, and Interdisciplinary Publications. If the content of an entry overlaps art forms, it is classified according to the discipline most stressed. Those entries dealing equally and comparatively with two or three art forms are listed under the section, Interdisciplinary Publications.

R.S. & E.K.
Wayne State University
Detroit, Michigan

Notes

1. Franklin W. Robinson and Stephen G. Nichols, Jr., eds., *The Meaning of Mannerism* (Hanover, N.H.: University Press of New England, 1972), p. 3.
2. See John Shearman, *Mannerism* (Harmondsworth, Middlesex, England: Penguin, 1969), pp. 51–60 and "Mannerism" in Harold Osborne, ed., *The Oxford Companion to Art* (Oxford & New York: Oxford University Press, 1970).
3. Henri Zerner, "The Use of the Concept of Mannerism," in Robinson and Nichols, p. 106.
4. See Branimir Anzulovic, "Mannerism in Literature: A Review of Research," *Yearbook of Comparative and General Literature*, No. 23 (1974), p. 55. This article is the most important contribution to the research of mannerist literature to date; it presents the previous studies of Mannerism and discusses the extent to which they influenced the development of literary Mannerism. Our discussion of literary Mannerism is indebted to this article.
5. See Anzulovic, p. 56.
6. Don Harran, " 'Mannerism' in the Cinquecento Madrigal?," *Mus Qtr*, 55 (October 1969): 522.
7. Glenn E. Watkins, *Gesualdo: The Man and His Music* (Chapel Hill: University of North Carolina Press, 1973), p. 110.

ABBREVIATIONS

AB	*Art Bulletin*
Archit R	*Architectural Review*
Art in Am	*Art in America*
Art Qtr	*Art Quarterly*
Burl Mag	*Burlington Magazine*
Coll Germ	*Colloquia Germanica*
Compar Lit	*Comparative Literature*
DA	*Dissertation Abstracts*
Gaz Beaux Arts	*Gazette des Beaux-Arts*
J Aesthetics	*Journal of Aesthetics and Art Criticism*
Jahr Kunsthist Sam Wien	*Jahrbuch der Kunsthistorischen Sammlungen in Wien*
L'Esp Créat	*L'Esprit Créateur*
Lit Jahr	*Literaturwissenschaftliches Jahrbuch*
Mus Qtr	*Musical Quarterly*
R Belge Archéol	*Revue Belge d'Archéologie et d'Histoire d'Art*
Riv Lett Mode Comp	*Rivista di Letterature Moderne e Comparate*
Yrbk Compar & Gen Lit	*Yearbook of Comparative and General Literature*
Z Kunstges	*Zeitschrift für Kunstgeschichte*

I. ART

I. ART

1. Ackerman, Gerald. "Gian Battista Marino's Contribution to Seicento Art Theory," *AB*, 43 (1961): 326–336.

2. Adeline, Jules. *The Adeline Art Dictionary.* New York: Ungar, 1966.

3. Adelmann, G. S. Graff and Georg Weise. *Das Fortleben Gotischer Ausdrucks und Bewegungsmotive in der Kunst des Manierismus.* Tübingen: Auslieferungsstelle im Kunsthistorischen Institut der Universität, 1954.

4. Alcaide, Victor Nieto. "La Vidriera Manierista en España: Obras Importadas y Maestros Procedentes de los Países Bajos," *Archivo Español de Arte*, 46 (1973): 93–130.

5. Andreyeff, Vera Shileyko. "The Romantic Current in Italian Art of the Sixteenth Century and Some Venetian Paintings in Moscow and Leningrad," *Art in Am*, 21 (1933): 122–131.

6. Angulo Iniguez, Diego. *Pintura del Renacimiento.* Madrid: Plus-Ultra, 1954.

7. Antal, Friedrich. "Observations on Girolamo Da Carpi," *AB*, 30 (1948): 81–103.

8. ———. "Zum Problem des Niederländischen Manierismus," *Kritische Berichte zur Kunstgeschichtlichen Literatur*, 1–2 (1927–1929): 207–256.

9. Arslan, Edoardo. "Appunti su Domenico Brusasorci e la Sua Cerchia," *Emporium*, 106 (1947): 15–28.

10. Auerbach, Erna. "Notes on Some Northern Mannerist Portraits," *Burl Mag*, 91 (1949): 218–222.

11. Avery, Catherine B., ed. *The New Century Italian Renaissance Encyclopedia*. New York: Appleton Century Crofts, 1972.

12. Babelon, Jean. "Le Maniérisme Septentrional et l'École de Fontainebleau" (see entry 209).

13. ———. "Mannerism in Northern Europe and the School of Fontainebleau" (see entry 211).

14. Baldass, Peter von, Rudolf Feuchtmüller and Wilhelm Mrazek. *Renaissance in Österreich*. Vienna: Forum, 1966.

15. Barbieri, Franco. "Palladio e il Manierismo," *International Center for the Study of Architecture*, 6 (1964): 49–63.

16. Barocchi, Paola. *Il Rosso Fiorentino*. Rome: Gismondi, 1950.

17. ———, ed. *Trattati d'Arte del Cinquecento fra Manierismo e Controriforma*. 3 vols. Bari: Laterza and Figli, 1960.

18. Baroni, Costantino. "Di Alcuni Sviluppi della Pittura Cremonese dal Manierismo al Barocco," *Emporium*, 103 (1946): 108–122.

19. Barron, John N. *The Language of Painting: An Informal Dictionary*. New York: World, 1967.

20. Battisti, Eugenio. *L'Antirinascimento*. Milan: Feltrinelli, 1962.

21. ———. *Hochrenaissance und Manierismus*. Baden-Baden: Holle, 1970.

22. ———. *Rinascimento e Barocco*. Turin: Einaudi, 1960.

23. ———. "Storia del Concetto de Manierismo in Architettura," *International Center for the Study of Architecture*, 9 (1967): 204–210.

24. Baumgart, Fritz Erwin. "Biagio Betti und Albrecht Dürer: Zur Raumvorstellung in der Malerei des Römisch-Bolognesischen Manierismus in der Zweiten Hälfte des 16. Jahrhunderts," *Z Kunstges*, 3 (1934): 231–249.

25. ———. *Renaissance und Kunst des Manierismus*. Cologne: du Mont Schauberg, 1963.

26. Bazin, Germain. *The Baroque: Principles, Styles, Modes, Themes*. trans. Pat Wardroper. Greenwich, Conn.: New York Graphic Society, 1968.

27. Becherucci, Luisa. *L'Architettura Italiana del Cinquecento*. Florence: Novissima Enciclopedia Monografica Illustrata, 1936.

28. ———. *Manieristi Toscani*. Bergamo: Istituto Italiano d'Arti Grafiche, 1944.

29. ———. *La Scultura Italiana del Cinquecento*. Florence: Novissima Enciclopedia Monografica Illustrata, 1934.

30. Béguin, Sylvie. *L'École de Fontainebleau*. Paris: Gonthier-Seghers, 1960.

31. ———. "Un Tableau de Luca Penni," *Revue du Louvre*, 25 (1975): 359–366.

32. Bellafiore, Giuseppe. *Dall'Islam alla Maniera: Profilo dell' Architettura Siciliana dal IX al XVI Secolo*. Palermo: Flaccovio, 1975.

33. Benesch, Otto. *The Art of the Renaissance in Northern Europe*. rev. ed. London: Phaidon, 1965.

34. Berenson, Bernard. *The Drawings of the Florentine Painters*. 3 vols. Chicago: University of Chicago Press, 1938.

35. ———. *The Italian Painters of the Renaissance*. New York: Meridian, 1957.

36. Bergmans, Simone. "Une Résurrection du Premier Quart du XVI^e Siècle Anversois Attribuable à Jan Van Dornicke Alias le Maître de 1518," *R Belge Archéol*, 40 (1971): 61–79.

37. Berti, Luciano. "L'Architettura Manieristica a Firenze e in Toscana," *International Center for the Study of Architecture*, 9 (1967): 211–218.

38. Białostocki, Jan. "Mannerism and Vernacular in Polish Art," in *Walter Friedlaender zum 90. Geburtstag*, ed. by Georg Kauffmann and Willibald Sauerlander. Berlin: de Gruyter, 1965.

39. Blunt, Anthony F. *Art and Architecture in France 1500–1700*. London: Penguin, 1953.

40. ———. *Artistic Theory in Italy 1450–1600*. Oxford: Clarendon Press, 1940.

41. ———. "Mannerism in Architecture," *Royal Institute of British Architects Journal*, series 3, 56 (1949): 195–201.

42. Bousquet, Jacques. *Malerei des Manierismus: Die Kunst Europas von 1520 bis 1620*. Munich: Bruckmann, 1963.

43. ———. *Mannerism: The Painting and Style of the Late Renaissance*. trans. Simon Watson Taylor. New York: Braziller, 1964.

44. ———. *La Peinture Manieriste*. Neuchâtel: Ides et Calendes, 1964.

45. Braunfels, Wolfgang, ed. *Knaurs Weltkunstgeschichte*. 2 vols. Munich: Droemer Knaur, 1964.

46. Briganti, Giuliano. *Italian Mannerism*. trans. Margaret Kunzle. Leipzig: VEB Edition, 1962.

47. ———. *Il Manierismo e Pellegrino Tibaldi*. Rome: Cosmopolita, 1945.

48. Brinckmann, A. E. *Barockskulptur: Entwicklungsgeschichte der Skulptur in den Romanischen und Germanischen Ländern seit Michelangelo bis zum Beginn des 18. Jahrhunderts*. Berlin: Athenaion, 1917.

49. Brizio, Anna Maria. "Manierismo: Rinascimento," *International Center for the Study of Architecture*, 9 (1967): 219–226.

50. Brookes, Peter Cannon. "Three Notes on Maso da San Friano" (see entry 55).

51. Bruand, Yves and Bruno Tollon. "L'Architecture Baroque Toulousaine: Mouvement Original ou Maniérisme Prolongé?" *Gaz Beaux Arts*, series 6, 80 (1972): 261–272.

52. Burckhardt, Jacob. *Der Cicerone*. 2 vols. in 3. Leipzig: Seemann, 1884.

53. Burger, Fritz, Hermann Schmitz and Ignaz Beth. *Die Deutsche Malerei vom Ausgehenden Mittelalter bis zum Ende der Renaissance*. 3 vols. Berlin: Athenaion, 1919.

54. Burgum, Edwin Berry. "Marxism and Mannerism: The Esthetic of Arnold Hauser," *Science and Society*, 32 (1968): 307–320.

55. *Burlington Magazine*, 107 (1965): 171–206. Special Renaissance through Baroque issue. For contents see entries 50, 134, 197, 305, 345.

56. Bury, John. "A Jesuit Façade in China," *Archit R*, 124 (1958): 412–413.

57. Campos, Deoclecio Redig de. "Discussione sul Manierismo" (see entry 363).

58. Casotti, Maria. "La Critica del Manierismo e Iacopo Barozzi da Vignola," *Aevum*, 25 (1951): 125–131.

59. Castelfranco, Giorgio. "Mannerist Sculpture, Grace and Perfection," *Formes*, no. 31 (1933): 350–351.

60. ———. "Norm of Europe: Mannerism," *Formes*, no. 17 (1931): 117–118.

61. Caturla, Maria Luisa. "El Manierismo," *Revista de Ideas Esteticas*, 2 (1944): 3–15.

62. Ceballos, Alfonso R. Gutiérrez de. "La Arquitectura del Manierismo," *Revista de Ideas Esteticas*, 20 (1962): 3–29.

63. Chaleix, Pierre. "Orants Oublies," *L'Oeil*, nos. 246–247 (1976): 26–29.

64. Chastel, André. *La Crise de la Renaissance 1520–1600*. Geneva: Skira, 1968.

65. ———. *The Crisis of the Renaissance 1520–1600*. trans. Peter Price. Geneva: Skira, 1968.

66. ———. *Italian Art*. trans. Peter and Linda Murray. New York: Yoseloff, 1963.

67. ———. "Le Maniérisme et l'Art du Cinquecento," *International Center for the Study of Architecture*, 9 (1967): 227–232.

68. ———. "What is Mannerism," trans. Anne Little, *Art News*, 64 (1965): 22–25.

69. Christoffel, Ulrich. "Leonardo, Correggio und die Manier," *Wallraf-Richartz Jahrbuch*, 14 (1952): 129–143.

70. Clark, Kenneth. *A Failure of Nerve: Italian Painting 1520–1535*. Oxford: Clarendon Press, 1967.

71. Cleaver, Dale G. *Art: An Introduction*. New York: Harcourt, Brace and World, 1966.

72. Cnattingius, Bengt. *Maerten van Heemskerck's St. Lawrence Altarpiece in Linköping Cathedral: Studies in its Manneristic Style*. Stockholm: Almqvist and Wiksell, 1973.

73. Cochrane, Eric. *Florence in the Forgotten Centuries 1527–1800*. Chicago: University of Chicago Press, 1973.

74. ———, ed. *The Late Italian Renaissance 1525–1630*. London: Macmillan, 1970.

75. Coe, Ralph T. "Zurbarán and Mannerism," *Apollo*, 96 (1972): 494–497.

76. Coletti, Luigi. "La Crisi Manieristica nella Pittura Veneziana," *Convivium*, 13 (1941): 109–126.

77. ———. "Intorno alla Storia del Concetto di Manierismo," *Convivium*, 17 (1948): 801–811.

78. Coolidge, John. "The Villa Giulia: A Study of Central Italian Architecture in the Mid-Sixteenth Century," *AB*, 25 (1943): 177–225.

79. Cooper, Martin. "Mannerism: The Anxious State," *Daily Telegraph*, 23 June 1973, p. 11.

80. Corbara, A. "Aspetti del Tardo Manierismo Faentino," *Melozzo da Forli*, 7 (1939): 338–351.

81. Cuttler, Charles D. *Northern Painting from Pucelle to Bruegel*. New York: Holt, Rinehart and Winston, 1968.

82. Daniels, Jeffery. "To the Manner Re-born," *Art and Artists*, 4 (1969): 54–55.

83. Davidson, J. L. "Mannerism and Neurosis in the Erotic Art of India," *Oriental Art*, 6 (1960): 82–90.

84. Decker, Heinrich. *The Renaissance in Italy: Architecture, Sculpture, Frescoes*. New York: Viking, 1969.

85. Delworth, P. O. "Mannerism and the Art of Our Times: Jean Duvet and Jacques Bellange," *Vie des Arts*, no. 58 (1970): 42–43.

86. *Dictionary of Italian Painting*. New York: Tudor, 1964.

87. Dimier, Louis. *French Painting in the Sixteenth Century*. trans. Harold Child. London: Duckworth, 1904.

88. ———. *Histoire de la Peinture Française: Des Origines au Retour de Vouet 1300 à 1627*. Paris: Librairie Nationale d'Art et d'Histoire, 1925.

89. ———. *Le Primatice*. Paris: Michel, 1928.

90. Dorra, Henri. *Art in Perspective: A Brief History*. New York: Harcourt, Brace and Jovanovich, 1972.

91. Du Colombier, Pierre. *L'Art Renaissance en France: Architecture, Sculpture, Peinture, Arts Graphiques, Arts Appliqués*. Paris: le Prat, 1945.

92. Dumont, Catherine. *Francesco Salviati au Palais Sacchetti de Rome et la Décoration Murale Italienne 1520–1560*. Rome: Istituto Suisse de Rome, 1973.

93. Durliat, M. "Baroque ou Maniérisme dans la Toulouse du Début de XVII^e Siecle," *Bulletin Monumental*, 131 (1973): 52–53.

94. Dvořák, Max. *Geschichte der Italienischen Kunst im Zeitalter der Renaissance*. 2 vols. Munich: Piper, 1928.

95. ———. "El Greco and Mannerism," trans. John Coolidge, *Magazine of Art*, 46 (1953): 14–23.

96. ———. *Kunstgeschichte als Geistesgeschichte: Studien zur Abendländischen Kunstentwicklung*. Munich: Piper, 1924.

97. Edgerton, Samuel Y., Jr. "Maniera and the Mannaia: Decorum and Decapitation in the Sixteenth Century" (see entry 605).

98. Eglinski, Edmund. *The Art of the Italian Renaissance*. Dubuque, Iowa: Brown, 1968.

99. Elliott, J. H. "Mannerism," *Horizon*, 15 (1973): 84–95.

100. *Enciclopedia dell'Arte Antica, Classica e Orientale*. 7 vols. Rome: Instituto dell'Enciclopedia Italiana, 1958.

101. *Enciclopedia Universale dell'Arte*. 15 vols. Florence: Sansoni, 1958.

102. *Encyclopedia of World Art*. 15 vols. New York: McGraw-Hill, 1959.

103. Enggass, Robert and Jonathan Brown. *Italy and Spain 1600–1750: Sources and Documents*. Englewood Cliffs, N.J.: Prentice-Hall, 1970.

104. Ernst, Loni. *Manieristische Florentiner Baukunst*. Potsdam: Athenaion, 1934.

105. Fagiolo Dell'Arco, Maurizio. *Il Parmigianino: Un Saggio Sull' ermetismo nel Cinquecento*. Rome: Bulzoni, 1970.

106. Fairholt, Frederick William, ed. *A Dictionary of Terms in Art*. London: Virtue, Hall and Virtue, 1854; reprint ed. Detroit: Gale Research, 1969.

107. Fasola, Giusta Nicco. "Giulio Romano e il Manierismo," *Commentari*, 11 (1960): 60–73.

108. ———. "Storiografia del Manierismo," in *Scritti di Storia dell'-Arte in Onore di Lionello Venturi*. 2 vols. Rome: de Luca, 1956, vol. 1, pp. 429–447.

109. Fernau, Joachim. *The Praeger Encyclopedia of Old Masters*. New York: Praeger, 1959.

110. Feulner, Adolf. *Die Deutsche Plastik des Siebzehnten Jahrhunderts*. Munich: Wolff, 1926.

111. Flamand, Elie Charles. *La Renaissance*. Lausanne: Recontre, 1966.

112. Fleming, John, Hugh Honour and Nikolaus Pevsner. *The Penguin Dictionary of Architecture*. 2nd ed. Harmondsworth: Penguin, 1974.

113. Fleming, William. *Arts and Ideas*. 3rd ed. New York: Holt, Rinehart and Winston, 1968.

114. Fletcher, Banister. *A History of Architecture on the Comparative Method*. 18th ed. New York: Scribner's, 1975.

115. Florisoone, Michel. "La Mystique Plastique du Greco et les Antécédents de Son Style," *Gaz Beaux Arts*, series 6, 49 (1957): 19–44.

116. Forssman, Erik. *Säule und Ornament: Studien zum Problem des Manierismus in den Nordischen Säulenbüchern und Vorlageblättern des 16. und 17. Jahrhunderts*. Stockholm: Almqvist and Wiksell, 1956.

117. Forster, Kurt. *Mannerist Painting: The Sixteenth Century*. New York: McGraw-Hill, 1966.

118. Frabetti, Giuliano. *Manieristi a Ferrara*. Milan: Silvana, 1972.

119. Franz, Heinrich Gerhard. *Niederländische Landschaftsmalerei im Zeitalter des Manierismus*. 2 vols. Graz: Druck, 1969.

120. Freedberg, Sydney Joseph. "Observations on the Painting of the Maniera," *AB*, 47 (1965): 187–197.

121. ———. *Painting in Italy 1500–1600*. Harmondsworth: Penguin, 1970.

122. ———. *Painting of the High Renaissance in Rome and Florence*. 2 vols. Cambridge: Harvard University Press, 1961.

123. ———. *Parmigianino: His Works in Painting.* Cambridge: Harvard University Press, 1950; reprint ed. Westport, Conn.: Greenwood Press, 1971.

124. Frey, Dagobert. *Gotik und Renaissance als Grundlagen der Modernen Weltanschauung.* Augsburg: Filser, 1929.

125. ———. *Manierismus als Europäische Stilerscheinung: Studien zur Kunst des 16. und 17. Jahrhunderts.* Stuttgart: Kohlhammer, 1964.

126. Friedländer, Max J. "Die Antwerpener Manieristen von 1520," *Jahrbuch der Koniglich Preuszischen Kunstsammlungen,* 36 (1915): 65–91.

127. Friedländer, Walter F. "Die Entstehung des Antiklassischen Stiles in der Italienischen Malerei um 1520," *Repertorium für Kunstwissenschaft,* 46 (1925): 49–86.

128. ———. *Mannerism and Anti-Mannerism in Italian Painting.* 2nd ed. New York: Schocken, 1965.

129. ———. "Mannerism and Anti-Mannerism in Italian Painting," in *Art History: An Anthology of Modern Criticism,* ed. by Wylie Sypher. New York: Vintage, 1963, pp. 259–275.

130. Frölich-Bum, Lili. *Parmigianino und der Manierismus.* Vienna: Schroll, 1921.

131. Gardner, Helen. *Art Through the Ages.* 6th ed. New York: Harcourt, Brace and Jovanovich, 1975.

132. Gaunt, William. *Everyman's Dictionary of Pictorial Art.* 2 vols. New York: Dutton, 1962.

133. Gavazza, Ezia. "Note sulla Pittura del Manierismo a Genova," *Critica d'Arte,* 3 (1956): 96–102.

134. Gere, John Arthur. "The Decoration of the Villa Giulia" (see entry 55).

135. ———. *Il Manierismo a Roma.* Milan: Fabbri, 1971.

136. ———. *Taddeo Zuccaro: His Development Studied in His Drawings.* Chicago: University of Chicago Press, 1969.

137. Gerson, Horst and E. H. ter Kuile. *Art and Architecture in Belgium 1600–1800.* Baltimore: Penguin, 1960.

138. Ginhart, Karl. *Wiener Kunstgeschichte.* Vienna: Neff, 1948.

139. Godfrey, F. M. *Italian Sculpture 1250–1700*. London: Tiranti, 1967.

140. ———. *A Student's Guide to Italian Painting 1250–1800*. 2nd ed. London: Tiranti, 1965.

141. Göransson, A. M. "Studies in Mannerism," *Konsthistorisk Tidskrift*, 38 (1969): 120–143.

142. Goering, Max. *Italienische Malerei des Sechzehnten Jahrhunderts*. Berlin: Wolff, 1935.

143. Goguel, Catherine Monbeig. "Filippo Bellini da Urbino della Scuola del Baroccio," *Master Drawings*, 13 (1975): 347–370.

144. Golzio, Vincenzo. *Seicento e Settecento*. 2 vols. 2nd ed. Turin: Unione Tipografico, Editrice Torinese, 1960.

145. Gombrich, Ernst Hans. "The Historiographic Background of the Concept of Mannerism" (see entry 363).

146. ———. *Norm and Form: Studies in the Art of the Renaissance*. London: Phaidon, 1966.

147. ———. "The Renaissance Concept of Artistic Progress and its Consequences," in *Acts of the Seventeenth International Congress of the History of Art*, 1955, pp. 291–307.

148. ———. *The Story of Art*. 12th ed. London: Phaidon, 1972.

149. ———. "Zum Werke Giulio Romanos: Der Palozzo Del Te," *Jahr Kunsthist Sam Wien*, 8 (1934): 79–104.

150. ———. "Zum Werke Giulio Romanos: Versuch Einer Deutung," *Jahr Kunsthist Sam Wien*, 9 (1935): 121–150.

151. Gómez Moreno, Manuel. *The Golden Age of Spanish Sculpture*. Greenwich, Conn.: New York Graphic Society, 1964.

152. Grassi, Luigi. *Problemi Intorno a Michelangelo e il Concetto di Maniera*. Rome: Ateneo, 1955.

153. Greenhill, Eleanor S. *Dictionary of Art*. New York: Dell, 1974.

154. Hagelberg, L. "Die Architektur Michelangelos in Ihren Beziehungen zu Manierismus und Barock," *Münchner Jahrbuch der Bildenden Kunst*, 8 (1931): 264–280.

155. Hager, Werner. "Zur Raumstruktur des Manierismus in der Italienischen Architektur," in *Festschrift Martin Wackernagel*. Cologne: Böhlau, 1958, pp. 112–140.

156. ———. "Strutture Spaziali del Manierismo nell'Architettura Italiana," *International Center for the Study of Architecture*, 9 (1967): 257-271.

157. Haggar, Reginald G. *A Dictionary of Art Terms: Painting, Sculpture, Architecture, Engraving and Etching, Lithography and Other Art Processes, Heraldry*. New York: Hawthorn, 1962.

158. Hale, John R. *Renaissance*. New York: Time, 1965.

159. Hamann, Richard. *Geschichte der Kunst von der Altchristlichen Zeit bis zur Gegenwart*. Berlin: Knaur, 1933.

160. Hamlin, Talbot. *Architecture Through the Ages*. New York: Putnam, 1940.

161. Hartt, Frederick. *Giulio Romano*. 2 vols. New Haven: Yale University Press, 1958.

162. ———. *History of Italian Renaissance Art: Painting, Sculpture, Architecture*. New York: Abrams, 1969.

163. ———. "Power and the Individual in Mannerist Art" (see entry 363).

164. ———. "Raphael and Giulio Romano," *AB*, 26 (1944): 67–94.

165. Haskell, Francis. "The Moment of Mannerism," *Encounter*, 35 (1970): 69–73.

166. Hatje, Ursula, ed. *The Styles of European Art*. trans. Wayne Dynes and Richard Waterhouse. London: Thames and Hudson, 1965.

167. Hauser, Arnold. "L'Ambiente Spirituale del Manierismo," *International Center for the Study of Architecture*, 9 (1967): 187–197.

168. ———. *Historia Social de la Literatura y el Arte*. 3 vols. trans. A. Tovar and F. P. Varas-Reyes. Madrid: Guadarrama, 1957.

169. ———. *El Manierismo: La Crisis del Renacimiento y los Origenes del Arte Moderno*. trans. Felipe Gonzalez Vicen. Madrid: Guadarrama, 1965.

170. ———. *Der Manierismus: Die Krise der Renaissance und der Ursprung der Modernen Kunst*. Munich: Beck, 1964.

171. ———. *Mannerism: The Crisis of the Renaissance and the Origin of Modern Art*. 2 vols. trans. Eric Mosbacher. London: Routledge and Kegan Paul, 1965.

172. ———. *The Philosophy of Art History*. New York: Knopf, 1959.

173. ———. *The Social History of Art*. 2 vols. trans. Stanley Godman. London: Routledge and Kegan Paul, 1951.

174. ———. *Sozialgeschichte der Kunst und Literatur*. 2 vols. Munich: Beck, 1953.

175. ———. *Soziologie der Kunst*. Munich: Beck, 1974.

176. Hayward, J. F. "The Mannerist Goldsmiths: Italian Sources and Some Drawings and Designs," *Connoisseur*, 149 (1962): 156–165.

177. ———. "The Mannerist Goldsmiths: France and the School of Fontainebleau, Part 1," *Connoisseur*, 152 (1963): 240–245.

178. ———. "The Mannerist Goldsmiths: France and the School of Fontainebleau, Part 2," *Connoisseur*, 153 (1963): 11–15.

179. ———. "The Mannerist Goldsmiths: Antwerp, Part 1," *Connoisseur*, 156 (1964): 92–96.

180. ———. "The Mannerist Goldsmiths: Antwerp, Part 2," *Connoisseur*, 156 (1964): 164–170.

181. ———. "The Mannerist Goldsmiths: Antwerp, Part 3," *Connoisseur*, 156 (1964): 250–254.

182. ———. "The Mannerist Goldsmiths: Antwerp, Part 4," *Connoisseur*, 158 (1965): 144–149.

183. ———. "The Mannerist Goldsmiths: England, Part 1," *Connoisseur*, 159 (1965): 80–84.

184. ———. "The Mannerist Goldsmiths: England, Part 2," *Connoisseur*, 162 (1966): 90–95.

185. ———. "The Mannerist Goldsmiths: England, Part 3," *Connoisseur*, 164 (1967): 19–25.

186. ———. "The Mannerist Goldsmiths: Germany, Part 1," *Connoisseur*, 164 (1967): 78–84.

187. ———. "The Mannerist Goldsmiths: Germany, Part 2," *Connoisseur*, 164 (1967): 148–154.

188. ———. "The Mannerist Goldsmiths: Germany, Part 3," *Connoisseur*, 164 (1967): 216–222.

189. ———. "The Mannerist Goldsmiths: Germany, Part 4," *Connoisseur*, 165 (1967): 162–167.

190. ———. "The Mannerist Goldsmiths: Germany, Part 5," *Connoisseur*, 168 (1968): 15–19.

191. ———. "The Mannerist Goldsmiths: Christoph Jamnitzer and His Contemporaries," *Connoisseur*, 168 (1968): 161–166.

192. ———. "The Mannerist Goldsmiths: Northern Germany, Part 7," *Connoisseur*, 175 (1970): 22–30.

193. ———. "Some Spurious Antique Vase Designs of the Sixteenth Century," *Burl Mag*, 114 (1972): 378–386.

194. Hempel, Eberhard. *Baroque Art and Architecture in Central Europe*. Harmondsworth: Penguin, 1965.

195. Henze, A. "Architektur als Labyrinth: Schloss Caprarola, der Musterbau des Manierismus," *Deutsche Bauzeitung*, 69 (1964): 961–964.

196. Hill, Ann. *A Visual Dictionary of Art*. Greenwich, Conn.: New York Graphic Society, 1974.

197. Hirst, Michael. "A Late Work of Sebastiano del Piombo" (see entry 55).

198. *Histoire de l'Art*. 4 vols. Paris: Gallimard, 1965.

199. Hocke, Gustav René. *Labyrinthe de l'Art Fantastique: Le Maniérisme dans l'Art Européen*. trans. Cornélius Heim. Paris: Gonthier, 1967.

200. ———. *Malerei der Gegenwart der Neo-Manierismus*. Munich: Limes, 1975.

201. ———. "Über Manierismus in Tradition und Moderne," *Merkur*, 10 (1956): 336-363.

202. Hoerner, Margarete. "Manierismus," *Zeitschrift für Ästhetik und Allgemeine Kunstwissenschaft*, 18 (1924): 262–268.

203. ———. "Der Manierismus als Künstlerische Anschauungsform," *Zeitschrift für Ästhetik und Allgemeine Kunstwissenschaft*, 22 (1928): 200–210.

204. Hoffmann, Hans. *Hochrenaissance, Manierismus, Frühbarock: Die Italienische Kunst des 16. Jahrhunderts*. Leipzig: Seeman, 1938.

205. Holst, Niels. "Die Deutsche Bildnismalerei zur Zeit des Manierismus," *Studien zur Deutschen Kunstgeschichte*, no. 273 (1930): 1–86.

206. Holt, Elizabeth Gilmore, ed. *A Documentary History of Art*. 2nd ed. 2 vols. Garden City: Anchor, 1958.

207. Hoogewerff, G. J. "Manierisme," *Nederlands Kunsthistorisch Jaarboek*, 6 (1955): 133–141.

208. "The Human Body," *Horizon*, 15 (1973): 96–103.

209. Huyghe, René, ed. *L'Art et l'Homme*. 3 vols. Paris: Larousse, 1961. For contents see entries 12, 270, 380.

210. ———. "Art Forms and Society: Mannerism in the Sixteenth Century" (see entry 211).

211. ———, ed. *Larousse Encyclopedia of Renaissance and Baroque Art*. New York: Prometheus Press, 1964. For contents see entries 13, 210, 269, 379.

212. ———. *Sens et Destin de l'Art*. 2 vols. Paris: Flammarion, 1967.

213. Isarlo, G. "Les Maniéristes Néerlandais," *Art et Artist*, n.s. 28 (1934): 289–297.

214. Ivanoff, Nicola. "Le Ignote Considerazioni di G. B. Volpato, sulla Maniera," in *Retorica e Barocco*. Rome: Bocca, 1955, pp. 99–109.

215. Iven, G. *Versuch Einer Deutung des Manierismus*. Cologne: Orthen, 1938.

216. Jahn, Johannes, ed. *Wörterbuch der Kunst*. 2nd ed. Stuttgart: Kröner, 1950.

217. Janson, Horst Woldemar. *History of Art: A Survey of the Major Visual Arts from the Dawn of History to the Present Day*. rev. ed. Englewood Cliffs, N.J.: Prentice-Hall, 1963.

218. Jordan, R. Furneaux. *A Concise History of Western Architecture*. London: Thames and Hudson, 1969.

219. Kaufmann, Emil. *Architecture in the Age of Reason: Baroque and Post-Baroque in England, Italy and France*. Cambridge: Harvard University Press, 1955.

220. Kauffmann, Georg. *Die Kunst des 16. Jahrhunderts*. Berlin: Propyläen, 1970.

221. Kauffmann, Hans. "Der Manierismus in Holland und die Schule von Fontainebleau," *Jahrbuch der Königlich Preuszischen Kunstsammlungen*, 44 (1923): 184–204.

222. Kehrer, Hugo Ludwig. *Greco als Gestalt des Manierismus.* Munich: Filser, 1939.

223. Keller, Harald. *The Renaissance in Italy: Painting, Sculpture, Architecture.* trans. Robert E. Wolf. New York: Abrams, 1969.

224. Klein, Robert and Henri Zerner. *Italian Art 1500–1600: Sources and Documents.* Englewood Cliffs, N.J.: Prentice-Hall, 1966.

225. Knell, Heiner and Hans Günther Sperlich, eds. *Ullstein Kunstlexikon.* Berlin: Ullstein, 1967.

226. Krönig, Wolfgang. "Zur Fruhzeit Jan Gossarts," *Z Kunstges,* 3 (1934): 163–177.

227. Kubler, George and Martin Soria. *Art and Architecture in Spain and Portugal and Their American Dominions 1500–1800.* Harmondsworth: Penguin, 1959.

228. Kusenberg, Kurt. "Autour du Rosso," *Gaz Beaux Arts,* series 6, 10 (1933): 158–172.

229. Lavedan, Pierre. "Contre-Réforme, Baroque, Maniérisme," *Gaz Beaux Arts,* series 6, 83 (1974): 97–116.

230. ———. *Histoire de l'Art.* 2 vols. Paris: Presses Universitaires de France, 1950.

231. Lavin, Irving. "An Observation on Medievalism in Early Sixteenth-Century Style," *Gaz Beaux Arts,* series 6, 50 (1957): 113–118.

232. Lee, Rensselaer W. "Ut Pictura Poesis: The Humanistic Theory of Painting," *AB,* 22 (1940): 197–269.

233. Levey, Michael. *A Concise History of Painting.* New York: Praeger, 1962.

234. ———. *High Renaissance.* Harmondsworth: Penguin, 1975.

235. *Lexikon der Kunst.* 3 vols. Leipzig: Seemann, 1975.

236. Lindhagen, Nils. "Studier i den Italienska Manierismens Porträttkonst," *Tidskrift för Konstvetenskap,* 25 (1944): 53–92.

237. Longaker, Jon D. *Art Style and History: A Selective Survey of Art.* Glenview, Ill.: Scott, Foresman, 1970.

238. Longhi, Roberto. "Comprimarj Spagnoli della Maniera Italiana," *Paragone,* 4 (1953): 3–15.

239. Lopez, Robert S. *The Three Ages of the Italian Renaissance.* Charlottesville, Va.: The University Press of Virginia, 1970.

240. Lotz, Wolfgang. "Architecture in the Later Sixteenth Century," *College Art Journal*, 17 (1958): 129–139.

241. ———. "Mannerism in Architecture: Changing Aspects" (see entry 363).

242. Lowenthal, Anne Walter. "Some Paintings by Peter Wtewael," *Burl Mag*, 116 (1974): 458–467.

243. McCarthy, Mary. *The Stones of Florence*. New York: Harcourt, Brace and World, 1959.

244. McComb, Arthur. *The Baroque Painters of Italy: An Introductory Historical Survey*. Cambridge: Harvard University Press, 1934.

245. Mahon, Denis. *Studies in Seicento Art and Theory*. London: Warburg Institute, 1947; reprint ed. Westport, Conn.: Greenwood Press, 1971.

246. "El Manierismo en Roma," *Goya*, no. 92 (1969): 125–126.

247. Martin, F. David. "On Enjoying Decadence," *J Aesthetics*, 17 (1959): 441–446.

248. Martin, John Rupert. "The Baroque from the Point of View of the Art Historian," *J Aesthetics*, 14 (1955): 164–171.

249. Martindale, Andrew. *Man and the Renaissance*. New York: McGraw-Hill, 1966.

250. Mayer, Ralph. *A Dictionary of Art Terms and Techniques*. New York: Crowell, 1969.

251. Michalski, Ernst. "Das Problem des Manierismus in der Italienischen Architektur," *Z Kunstges*, 2 (1933): 88–109.

252. Milesi, Richard. *Manierismus in Kärnten: Zur Kunst des Späten 16. Jahrhunderts*. Klagenfurt: Selbstverlag des Landesmuseums für Kärnten, 1973.

253. Mills, John FitzMaurice. *The Pergamon Dictionary of Art*. New York: Pergamon, 1965.

254. Monteverdi, Mario, ed. *Italian Art to 1850*. New York: Watts, 1965.

255. Müller Hofstede, Justus. "Jacques de Backer: Ein Vertreter der Florentinisch-Römischen Maniera in Antwerpen," *Wallraf-Richartz Jahrbuch*, 35 (1973): 227–260.

256. Mullaly, Terence. "The Relevance of Mannerism," *Daily Telegraph*, 6 June 1970, p. 9.

257. Murray, Linda. *The Late Renaissance and Mannerism.* New York: Praeger, 1967.

258. Murray, Peter. *The Architecture of the Italian Renaissance.* New York: Schocken, 1963.

259. ———— and Linda Murray. *Dictionary of Art and Artists.* 3rd ed. Baltimore: Penguin, 1972.

260. Myers, Bernard S. *Art and Civilization.* 2nd ed. New York: McGraw-Hill, 1967.

261. ————, ed. *Encyclopedia of Painting: Painters and Painting of the World from Prehistoric Times to the Present Day.* 3rd rev. ed. New York: Crown, 1970.

262. ————, ed. *McGraw-Hill Dictionary of Art.* 5 vols. New York: McGraw-Hill, 1969.

263. *The New International Illustrated Encyclopedia of Art.* 24 vols. New York: Greystone Press, 1971.

264. Niccoli, Alessandro, ed. *Enciclopedia dell'Arte Tumminelli.* 4 vols. Rome: Tumminelli, 1968.

265. Norberg-Schulz, Christian. *Meaning in Western Architecture.* New York: Praeger, 1975.

266. Osborne, Harold, ed. *The Oxford Companion to Art.* Oxford: Clarendon Press, 1970.

267. Osten, Gert von der and Horst Vey. *Painting and Sculpture in Germany and the Netherlands 1500–1600.* trans. Mary Hottinger. Harmondsworth: Penguin, 1969.

268. Pacheco, Francisco. *Arte de la Pintura.* 2 vols. Madrid: Instituto de Valencia de Don Juan, 1956.

269. Palluchini, Rodolfo. "The First Italian Mannerism and the New Conception of Reality" (see entry 211).

270. ————. "Le Premier Maniérisme Italien et la Nouvelle Conception de la Réalité" (see entry 209).

271. ————. "La Vicenda Italiana del Greco," *Paragone,* 4 (1953): 24–39.

272. Pane, Roberto. "I Quattro Libri dell'Architettura," *International Center for the Study of Architecture,* 1 (1959): 45–56.

273. Panofsky, Erwin. *Essais d'Iconologie: Thèmes Humanistes dans l'Art de la Renaissance.* trans. Claude Herbette and Bernard Teyssèdre. Paris: Gallimard, 1967.

274. ———. *Idea: A Concept in Art Theory*. trans. Joseph J. S. Peake. Columbia: University of South Carolina Press, 1968.

275. ———. *Idea: Ein Beitrag zur Begriffsgeschichte der Ältern Kunsttheorie*. 2nd ed. Berlin: Hessling, 1960.

276. ———. *Meaning in the Visual Arts: Papers in and on Art History*. Garden City: Anchor, 1955.

277. ———. *Studies in Iconology: Humanistic Themes in the Art of the Renaissance*. New York: Harper and Row, 1962.

278. Parow, Rolf and Hans E. Pappenheim. *Kunststile-Kunstsprache: Zwei Lexika*. Munich: Kunst und Technik, 1957.

279. Pevsner, Nikolaus. *Academies of Art Past and Present*. Cambridge: Cambridge University Press, 1940.

280. ———. "The Architecture of Mannerism," in *The Mint: A Miscellany of Literature, Art and Criticism*, ed. by Geoffrey Grigson. London: Routledge and Kegan Paul, 1946, pp. 116–138.

281. ——— and Otto Grautoff. *Barockmalerei in den Romanischen Ländern*. Wildpark-Potsdam: Athenaion, 1928.

282. ———. "Double Profile: A Reconsideration of the Elizabethan Style as Seen at Wollaton," *Archit R*, 107 (1950): 147–153.

283. ———. "Gegenreformation und Manierismus," *Repertorium für Kunstwissenschaft*, 46 (1925): 243–262.

284. ———. "L'Inghilterra e il Manierismo," *International Center for the Study of Architecture*, 9 (1967): 293–303.

285. ———. "Mannerism and Architecture," *Archit R*, 96 (1944): 184.

286. ———. "Mannerism and Elizabethan Architecture," *Listener*, 71 (1964): 350–352.

287. ———. *An Outline of European Architecture*. 7th ed. Harmondsworth: Penguin, 1963.

288. ———. "Palladio e il Manierismo," *International Center for the Study of Architecture*, 9 (1967): 304–309.

289. ———. "Tintoretto and Mannerism," *Archit R*, 111 (1952): 360–365.

290. Piel, Friedrich. "Zum Problem des Manierismus in der Kunstgeschichte," *Literaturwissenschaftliches Jahrbuch*, n.f. 2 (1961): 207–218.

291. Pijoán, José, ed. *El Arte del Renacimiento en el Norte y el Centro de Europa*. 3rd ed. Madrid: Espasa-Calpe, 1963.

292. Pilcher, Donald. "Temple of Deliverance," *Archit R*, 108 (1950): 307–314.

293. Pinder, Wilhelm. *Die Deutsche Plastik vom Ausgehenden Mittelalter bis zum Ende der Renaissance*. 2 vols. Wildpark-Potsdam: Athenaion, 1929.

294. ————. "Zur Physiognomik des Manierismus," in *Die Wissenschaft am Scheidewege*. Leipzig: Barth, 1932, pp. 148–156.

295. Pochat, Götz. "On Mannerism," *Konsthistorisk Tidskrift*, 38 (1969): 58–64.

296. Pope-Hennessy, John. *An Introduction to Italian Sculpture*. 3 vols. 2nd ed. London: Phaidon, 1972.

297. ————. "Nicholas Hilliard and Mannerist Art Theory," *Journal of the Warburg and Courtauld Institutes*, 6 (1943): 89–100.

298. Portoghesi, Paolo. *Borromini*. London: Thames and Hudson, 1968.

299. *Praeger Encyclopedia of Art*. 5 vols. New York: Praeger, 1971.

300. *The Praeger Picture Encyclopedia of Art: A Comprehensive Survey of Painting, Sculpture, Architecture and Crafts, Their Methods, Styles and Technical Terms from the Earliest Times to the Present Day*. New York: Praeger, 1958.

301. Praz, Mario. "Bizarre Sculpture: Byways of Italian Mannerism and the Baroque," *Art News Annual*, no. 26 (1957): 68–85.

302. Puyvelde, Leo van. *Considérations sur les Maniéristes Flamands*. reprint ed. from *La Revue Belge d'Archéologie et d'Histoire de l'Art*, 29 (1960).

303. ————. *La Renaissance Flamande de Bosch à Breughel*. Brussels: Meddens, 1971.

304. Ragghianti, Carlo Ludovico. "I Carracci e la Critica d'Arte nell'età Barocca," *La Critica*, 31 (1933): 65–74.

305. Ramsden, E. H. "Further Evidence on a Problem Picture" (see entry 55).

306. Randall, R. H., Jr. "A Mannerist Jewel," *Apollo*, 87 (1968): 176–178.

307. Read, Herbert Edward. *The Art of Sculpture*. 2nd ed. New York: Pantheon, 1956.

308. ———, ed. *Encyclopedia of the Arts*. New York: Meredith Press, 1966.

309. Réau, Louis. *French Painting in the Fourteenth, Fifteenth and Sixteenth Centuries*. trans. Mary Chamot. New York: Hyperion, 1939.

310. Redona Begni, P. "La Pittura Manieristica," *Storia di Breocia*, 3 (1964): 529–588.

311. Rehbein, Günther. *Malerei und Skulptur des Deutschen Früh-Manierismus*. Würzburg: Konrad Triltsch, 1939.

312. Reinhardt, Ursula. "La Tapisserie Feinte: Un Genre de Décoration du Maniérisme Romain au XVIᵉ Siecle," *Gaz Beaux Arts*, series 6, 84 (1974): 285–296.

313. Renzio, Toni del. "Palladio and the Art of the Maniera," *Art and Artists*, 10 (1975): 14–21.

314. Revel, Jean François. "Une Invention du XXᵉ Siècle, le Maniérisme," *L'Oeil*, no. 131 (1965): 2–15.

315. Reznicek, E. K. J. "Enkele Manieristische Tekeningen vit de Verzameling de Grez," *Oud Holland*, 71 (1956): 165.

316. ———. "Realism as a Side Road or Byway in Dutch Art" (see entry 363).

317. Rifkin, Benjamin A. "The Danube Mannerists," *Art News*, 68 (1970): 56–58.

318. Robb, David M. *The Harper History of Painting: The Occidental Tradition*. New York: Harper and Row, 1951.

319. Romano, Giovanni. *Casalesi del Cinquecento: L'Avvento del Manierismo in una Citta Padana*. Turin: Einaudi, 1970.

320. Roosval, Johnny. "Les Peintures des Retables Neerlandais en Suede," *R Belge Archéol*, 4 (1934): 311–320.

321. Rosenberg, Jakob, Seymour Slive and E. H. ter Kuile. *Dutch Art and Architecture 1600–1800*. Harmondsworth: Penguin, 1966.

322. Rosenthal, Earl. "Changing Interpretations of the Renaissance in the History of Art," in *The Renaissance: A Reconsideration of the Theories and Interpretations of the Age*, ed. by Tinsley Helton. Madison: University of Wisconsin Press, 1961, pp. 53–70.

323. Rosenthal, Gertrude. "Bacchiacca: Mannerist with Perfect Manners," *Art News*, 59 (1961): 42–44.

324. Rowe, Colin. "Mannerism and Modern Architecture," *Archit R*, 107 (1950): 289–299.

325. Runes, Dagobert D. and Harry G. Schrickel. *Encyclopedia of the Arts*. New York: Philosophical Library, 1946.

326. Ruskin, Ariane. *Art of the High Renaissance*. New York: McGraw-Hill, 1968.

327. Russell, Douglas A. "Mannerism and Shakespearean Costume," *Educational Theatre Journal*, 16 (1964): 324–332.

328. Russoli, Franco. *Renaissance Painting*. New York: Viking, 1962.

329. Salmi, Mario. "La Mostra del Cinquecento Toscano a Palazzo Strozzi," *Nuova Antologia*, no. 410 (1940): 75–83.

330. ———. "Rinascimento, Classicismo e Anticlassicismo," *Rinascimento*, series 2, 6 (1966): 3–26.

331. ———. "Tardo Rinascimento e Primo Barocco," in *Manierismo, Barocco, Rococò: Concetti e Termini*. Rome: Accademia Nazionale dei Lincei, quaderno 52, 1962, pp. 305–317.

332. Satin, Joseph. *The Humanities Handbook*. New York: Holt, Rinehart and Winston, 1969.

333. Schaffran, Emerich. *Dictionary of European Art*. trans. Kenneth Northcott. New York: Philosophical Library, 1958.

334. Schahl, Adolf. "Beitrage zur Plastik des Manierismus in Oberschwaben: Jakob Bendel, David Weiss, Hans Dürer, Georg Grassender," *Das Münster*, 14 (1961): 361–367.

335. Scheffler, Karl. "Über die Entstehung des Manierismus," *Werk*, 31 (1944): 169–171.

336. Schlosser, Julius Ritter von. *Die Kunstliteratur: Ein Handbuch zur Quellenkunde der Neueren Kunstgeschichte*. Vienna: Schroll, 1924.

337. ———. *La Letteratura Artistica: Manuale delle Fonti della Storia dell'Arte Moderna*. 2nd ed. Florence: La Nu Italia, 1956.

338. Schneider, René. *La Peinture Italienne*. 2 vols. Paris: Van Oest, 1930.

339. Serrão, Vitor Manuel. *A Pintura Manierista em Santarém*. Lisbon: Imprensa de Ciombra, 1971.

340. Sewall, John Ives. *A History of Western Art*. rev. ed. New York: Holt, Rinehart and Winston, 1961.

341. Shearman, John. "Maniera as an Aesthetic Ideal" (see entry 363).

342. ———. "Maniera as an Aesthetic Ideal," in *Renaissance Art*, ed. by Gilbert Creighton. New York: Harper and Row, 1970, pp. 181–221.

343. ———. *Mannerism*. Harmondsworth: Penguin, 1967.

344. ———. "In Search of a Definition: Three Books on Mannerism," *Apollo*, 81 (1965): 73–77.

345. ———. "Titian's Portrait of Giulio Romano" (see entry 55).

346. Shestack, Alan. "The Bizarre Mannerist Etchings of Jacques Bellange," *Art News*, 75 (1976): 45–47.

347. Simone, Margherita de. *Manierismo Architettonico nel Cinquecento Palermitano*. Palermo: Lo Monaco, 1968.

348. Smart, Alastair. *The Renaissance and Mannerism in Italy*. London: Thames and Hudson, 1971.

349. ———. *The Renaissance and Mannerism in Northern Europe and Spain*. London: Thames and Hudson, 1972.

350. ———. *The Renaissance and Mannerism Outside Italy*. London: Thames and Hudson, 1972.

351. Smyth, Craig Hugh. "The Earliest Works of Bronzino," *AB*, 31 (1949): 184–210.

352. ———. "Mannerism and Maniera" (see entry 363).

353. ———. *Mannerism and Maniera*. Locust Valley, N.Y.: Augustin, 1963.

354. Soby, James Thrall. "The Mannerist Movement," *Saturday Review*, 37 (1954): 33–34.

355. Sormani, Giuseppe, ed. *Dizionario delle Arti*. 5th ed. 2 vols. Novara: Istituto Geografico de Agostini, 1964.

356. Spencer, Harold, ed. *Readings in Art History*. 2 vols. New York: Scribner's, 1969.

357. Spina Barelli, Emma. *Teorici e Scrittori d'Arte tra Manierismo e Barocco*. Milan: Vita e Pensiero, 1966.

358. Stechow, Wolfgang. *Northern Renaissance Art 1400–1600: Sources and Documents*. Englewood Cliffs, N.J.: Prentice-Hall, 1966.

359. Steegman, John. "Mannerist Paintings in Canada," *Canadian Art*, 23 (1966): 10–13.

360. Stites, Raymond S. *The Arts and Man*. New York: McGraw-Hill, 1940.

361. Stokes, Adrian Durham. *Michelangelo: A Study in the Nature of Art*. London: Tavistock, 1955.

362. Stokstad, Marilyn. *Renaissance Art Outside Italy*. Dubuque, Iowa: Brown, 1968.

363. *Studies in Western Art: Acts of the Twentieth International Congress of the History of Art*. Princeton: Princeton University Press, 1963. For contents see entries 57, 145, 163, 241, 316, 341, 352.

364. Summers, David. "Maniera and Movement: The Figura Serpentinata," *Art Qtr*, 35 (1972): 269–301.

365. Summerson, John. *Architecture in Britain 1530–1830*. 4th ed. Harmondsworth: Penguin, 1963.

366. Sutton, Denys. "Mannerism: The Art of Permanent Ambiguity," *Apollo*, 81 (1965): 222–227.

367. Sypher, Wylie. *Rococo to Cubism in Art and Literature*. New York: Random House, 1960.

368. Tafuri, Manfredo. *L'Architettura del Manierismo nel Cinquecento Europeo*. Rome: Officina Edizioni, 1966.

369. Taylor, R. C. "Francisco Hurtado and His School," *AB*, 32 (1950): 25–61.

370. Terzaghi, Antonio. "La Nascita del Barocco e l'Esperienza Europea di Federico Zuccari," in *Acts of the Nineteenth International Congress of the History of Art*, 1958, pp. 285–297.

371. Thirion, Jacques. "Les Statues de Germain Pilon pour le Maître Autel de l'Église de la Couture au Mans," *Monuments et Mémoires*, 60 (1976): 133–150.

372. Tiberia, Vitaliano. *Giacomo Della Porta: Un Architetto tra Manierismo e Barocco*. Rome: Bulzoni, 1974.

373. Tomlinson, Anna. "Sacri Monti," *Archit R*, 116 (1954): 368–373.

374. Treves, Marco. "Maniera: The History of a Word," *Marsyas*, 1 (1941): 69–88.

375. Upjohn, Everard M., Paul S. Wingert and Jane Gaston Mahler. *History of World Art*. 2nd ed. New York: Oxford University Press, 1958.

376. Valentiner, Elisabeth. "Manierismus," *Z Kunstges*, 3 (1934): 212–217.

377. ———. "Manierismus," *Z Kunstges*, 4 (1935): 182–186.

378. Vanbeselaere, Walther. *Peter Bruegel en het Nederlandsche Manierismus*. Tielt: Lannoo, 1944.

379. Venturi, Lionello. "The Development of Italian Mannerism after 1550" (see entry 211).

380. ———. "L'Essor du Maniérisme Italien après 1550" (see entry 209).

381. ———. *History of Art Criticism*. trans. Charles Marriott. New York: Dutton, 1936.

382. ———. *Italian Painting*. 3 vols. trans. Stuart Gilbert. Geneva: Skira, 1951.

383. ———. *The Sixteenth Century from Leonardo to El Greco*. trans. Stuart Gilbert. New York: Skira, 1956.

384. Vincent, Jean Anne. *History of Art*. New York: Barnes and Noble, 1955.

385. Voss, Hermann. *Die Malerei der Spätrenaissance in Rom und Florenz*. 2 vols. Berlin: Grotesche, 1920.

386. Wackernagel, Martin. "Form und Stil," in *Das Atlantisbuch der Kunst*. Zurich: Atlantis, 1952, pp. 329–343.

387. ———. *Renaissance, Barock und Rokoko*. 2 vols. Berlin: Ullstein, 1964.

388. Wagner, Hugo. *Andrea del Sarto: Seine Stellung zu Renaissance und Manierismus*. Basel: Buchdrucherei zum Basler, 1950.

389. Wald, Ernest T. de. *Italian Painting 1200–1600*. New York: Holt, Rinehart and Winston, 1961.

390. Wallis, Anne Armstrong. "A Pictorial Principle of Mannerism," *AB*, 21 (1939): 280–283.

391. Waterhouse, Ellis. *Italian Baroque Painting*. 2nd ed. London: Phaidon, 1969.

392. Weisbach, Werner. *Der Barock als Kunst der Gegenreformation*. Berlin: Cassirer, 1921.

393. ———. "Barock als Stilphänomen," *Deutsche Vierteljahrsschrift für Literaturwissenschaft und Geistesgeschichte*, 2 (1924): 225–256.

394. ———. "Gegenreformation, Manierismus, Barock," *Repertorium für Kunstwissenschaft*, 49 (1928): 16–28.

395. ———. "Die Klassische Ideologie," *Deutsche Vierteljahrsschrift für Literaturwissenschaft und Geistesgeschichte*, 11 (1933): 559–591.

396. ———. "Der Manierismus," *Zeitschrift für Bildende Kunst*, n.s. 30, 54 (1918–1919): 161–183.

397. ———. "Zum Problem des Manierismus," *Studien zur Deutschen Kunstgeschichte*, no. 300 (1934): 15–20.

398. ———. *Spanish Baroque Art*. Cambridge: Cambridge University Press, 1941.

399. Weise, Georg. "La Doppia Origine del Concetto di Manierismo," in *Studi Vasariani*. Florence: Sansoni, 1952, pp. 181–185.

400. ———. "Maniera und Pellegrino: Zwei Lieblingswörter der Italienischen Literatur der Zeit des Manierismus," *Romanistisches Jahrbuch*, 3 (1950): 321–403.

401. ———. *Il Manierismo: Bilancio Critico del Problema Stilistico e Culturale*. Florence: Olschki, 1971.

402. ———. "Storia del Termine Manierismo," in *Manierismo, Barocco, Rococò: Concetti e Termini*. Rome: Accademia Nazionale dei Lincei, quaderno 52, 1962, pp. 27–38.

403. Wethey, Harold E. *El Greco and His School*. 2 vols. Princeton: Princeton University Press, 1962.

404. Whinney, Margaret. *Sculpture in Britain 1530–1830*. Harmondsworth: Penguin, 1964.

405. Wiemann, Hermann. *Die Malerei des Barock*. Hamburg: Cigaretten-Bilderdienst, 1940.

406. Wittkower, Rudolf. *Art and Architecture in Italy 1600–1750*. 3rd ed. Harmondsworth: Penguin, 1973.

407. ———. "Michelangelo's Biblioteca Laurenziana," *AB*, 16 (1934): 123–218.

408. Wölfflin, Heinrich. *The Art of the Italian Renaissance*. New York: Putnam, 1913.

409. ———. *Classic Art: An Introduction to the Italian Renaissance.* 2nd ed. trans. Peter and Linda Murray. London: Phaidon, 1953.

410. ———. *Renaissance and Baroque.* trans. Kathrin Simon. Ithaca: Cornell University Press, 1966.

411. Wolf, Martin L. *Dictionary of Painting.* New York: Philosophical Library, 1958.

412. Wolf, Robert Erich and Ronald Millen. *Renaissance and Mannerist Art.* New York: Abrams, 1968.

413. Würtenberger, Franzsepp. *Mannerism: The European Style of the Sixteenth Century.* trans. Michael Heron. New York: Holt, Rinehart and Winston, 1963.

414. Wüsten, Ernst. *Die Architektur des Manierismus in England.* Leipzig: Seemann, 1951.

415. Wundram, Manfred. *Art of the Renaissance.* trans. Francisca Garvie. New York: Universe, 1972.

416. Yarwood, Doreen. *The Architecture of Italy.* New York: Harper and Row, 1969.

417. Young, Eric. "Renaissance and Mannerist Painting in Spain," *Apollo*, 81 (1965): 206–215.

418. Zahn, Leopold. *Geschichte der Kunst von der Höhlenmalerei bis zum 20. Jahrhundert.* Gütersloh: Bertelsmann, 1963.

419. ———. "Neue Manierismus Literatur," *Das Kunstwerk*, 16 (1963): 88.

420. Zerner, Henri. *École de Fontainebleau: Gravures.* Paris: Arts et Metiers Graphiques, 1969.

421. ———. "Ghisi et la Gravure Maniériste à Mantoue," *L'Oeil*, no. 88 (1962): 26–33.

422. ———. "Observations on the Use of the Concept of Mannerism" (see entry 605).

423. ———. *The School of Fontainebleau: Etchings and Engravings.* trans. Stanley Baron. New York: Abrams, 1969.

424. ———. *Die Schule von Fontainebleau: Das Graphische Werk.* Munich: Schroll, 1969.

425. Zupnick, Irving L. "The Aesthetics of the Early Mannerists," *AB*, 35 (1953): 302–306.

426. ———. "Pontormo's Early Style," *AB*, 47 (1965): 345–353.

II. EXHIBITIONS AND RELATED PUBLICATIONS

II. EXHIBITIONS AND RELATED PUBLICATIONS

427. *An Age of Elegance and Sophistication: Painting at the Courts of Fontainebleau and Prague.* London: Arcade Gallery, 1956.

428. *Art in Italy 1600–1700.* Detroit: Detroit Institute of Arts, 1965.

429. *The Art of Mannerism.* New York: Delius Gallery, 1955.

430. *The Art of Mannerism in Italy, France and the Netherlands from 1520 to 1620.* London: Arcade Gallery, 1950.

431. *Bacchiacca and His Friends.* Baltimore: Baltimore Museum of Art, 1961.

432. *Between Renaissance and Baroque: European Art 1520–1600.* Manchester: Manchester City Art Gallery, 1965.

433. *Dutch Mannerism: Apogee and Epilogue.* Poughkeepsie, New York: Vassar College Art Gallery, 1970.

434. *L'École de Fontainebleau.* Paris: Grand Palais, 1973.

435. *Het Eerste Manierisme in Italië 1500–1540.* Amsterdam: Rijksmuseum, 1954.

436. *England and the Seicento: A Loan Exhibition of Bolognese Paintings from British Collections.* London: Agnew and Sons, 1973.

437. *Fontainebleau: Art in France 1528–1610.* 2 vols. Ottawa: National Gallery of Canada, 1973.

438. *French Art of the Sixteenth Century.* Jacksonville, Florida: Cummer Gallery of Art, 1964.

439. Grzimek, Günther. *Vom Aufgang der Neuzert Handbuch von Gemalden des Europäischen Manierismus: Katalog der Sammlung der Familie Grzimek.* Ravensburg: Grzimek, 1966.

440. Haraszti Takács, Marianne. *The Masters of Mannerism.* New York: Taplinger, 1968.

441. *The Human Figure in Italian Art 1520–1580.* Cambridge: Fogg Art Museum, 1962.

442. *Mannerism and the North European Tradition: Prints from c. 1520– c. 1630.* London: Colnaghi Gallery, 1974.

443. *Mannerist and Baroque Pictures from Italy and Holland.* London: Arcade Gallery, 1953.

444. *Mostra del Manierismo Piemontese e Lombardo del Seicento.* Turin: Museo Civico, 1955.

445. *Mostra del Pontormo e del Primo Manierismo Fiorentino.* Florence: Palazzo Strozzi, 1956.

446. *Mostra di Chiaroscuri Italiani dei Secoli XVI, XVII, XVIII.* Florence: Olschki, 1956.

447. *Mostra di Disegni Bolognesi dal XVI al XVIII Secolo.* Florence: Olschki, 1973.

448. *Mostra di Disegni Degli Zuccari.* Florence: Olschki, 1966.

449. *Mostra di Disegni dei Primi Manieristi Italiani.* Florence: Olschki, 1954.

450. *Pittori Bolognesi del Seicento nell Gallerei di Firenze.* Florence: Sansoni, 1975.

451. *Pontormo to Greco: The Age of Mannerism.* Indianapolis: John Herron Art Museum, 1954.

452. *The School of Fontainebleau: An Exhibition of Paintings, Drawings, Engravings, Etchings and Sculpture 1530–1619.* Fort Worth: Fort Worth Art Center, 1965.

453. *Le Triomphe du Maniérisme Européen de Michelange au Gréco.* Amsterdam: Rijksmuseum, 1955.

454. *Twenty Mannerist, Baroque and Rococo Paintings.* London: Arcade Gallery, 1957.

455. *The Virtuoso Craftsman: Northern European Design in the Sixteenth Century.* Worcester: Worcester Art Museum, 1969.

III. LITERATURE

III. LITERATURE

456. Alonso, Dámaso. *Poesia Española: Ensayo de Metodos y Limites Estilisticos.* Madrid: Gredos, 1952.

457. ———— and Carlos Bousoño. *Seis Calas en la Expresion Literaria Española.* 3rd ed. Madrid: Gredos, 1963.

458. Anzulovic, Branimir. "Mannerism in Literature: The Adventures of a Concept," Diss., Indiana University, *DA*, 33 (1973): 2680.

459. ————. "Mannerism in Literature: A Review of Research," *Yrbk Compar & Gen Lit*, no. 23 (1974): 54–66.

460. Barcklow, Brigitte. *Die Begriffe Barock und Manierismus in der Heutigen Shakespeare Forschung.* Freiburg: Krause, 1972.

461. Boase, A. M. "The Definition of Mannerism," in *Proceedings of the Third Congress of the International Comparative Literature Association.* The Hague: Mouton, 1962, pp. 143–155.

462. Borgerhoff, E. B. O. "Mannerism and Baroque: A Simple Plea," *Compar Lit*, 5 (1953): 323–331.

463. Brahmer, Mieczyslav. "Le Maniérisme: Terme d'Histoire Littéraire," in *La Littérature Comparée en Europe Orientale.* Budapest: Akadeniai Kiado, 1963, pp. 251–257.

464. Burck, Erich. *Vom Römischen Manierismus*. Darmstadt: Wissenschaftliche Buchgesellschaft, 1971.

465. Burgess, Robert M. "Mannerism in Philippe Desportes," *L'Esp Créat*, 6 (1966): 270–281.

466. Campagnoli, Ruggero. "Su Jodelle e il Manierismo," *Riv Lett Mod e Comp*, 25 (1972): 5–49.

467. Capua, A. G. de. "Baroque and Mannerism: Reassessment 1965," *Coll Germ*, 1 (1967): 101–110.

468. Carozza, Davy A. "For A Definition of Mannerism: The Hatzfeldian Thesis," *Coll Germ*, 1 (1967): 66–77.

469. Curtius, Ernst Robert. *Europäische Literatur und Lateinisches Mittelalter*. Bern: Francke, 1948.

470. ———. *European Literature and the Latin Middle Ages*. trans. Willard R. Trask. New York: Pantheon, 1953.

471. Daniells, Roy. "The Mannerist Element in English Literature," *University of Toronto Quarterly*, 36 (1966): 1–11.

472. ———. "Milton and Renaissance Art," in *John Milton: Introductions*. ed. by John Broadbent. Cambridge: Cambridge University Press, 1973, pp. 186–207.

473. ———. *Milton, Mannerism and Baroque*. Toronto: University of Toronto Press, 1963.

474. Demetz, Peter, Thomas Greene and Lowry Nelson, Jr., eds. *The Disciplines of Criticism*. New Haven: Yale University Press, 1968.

475. Drost, Wolfgang. "Strukturprobleme des Manierismus in Literature und Bildender Kunst: Vicenzo Giusti und die Malerei des 16. Jahrhunderts," *Arcadia*, 7 (1972): 12–36.

476. Durán, Manuel. "Lope de Vega y el Problema del Manierismo," *Anuario de Letras*, 2 (1962): 76–98.

477. Ferrero, Giuseppe Guido. *Marino e i Marinisti*. Milan: Ricciardi, 1954.

478. Friedrich, Hugo. *Epochen der Italienischen Lyrik*. Frankfurt: Klostermann, 1964.

479. ———. "Manierismus," in *Literatur II*, ed. by Friedrich Wolf-Hartmut and Walther Killy. Frankfurt: Fischer, 1965, pp. 353–358.

480. ———. "Über die 'Silvae' des Statius und die Frage des Literarischen Manierismus," in *Wort und Text: Festschrift für Fritz Schalk*. Frankfurt: Klostermann, 1963, pp. 34–56.

481. Fujii, Haruhiko. "Wavering Cone: 'Paradise Lost' and Forms of Mannerism," *Rising Generation*, 119 (1973): 458–459.

482. Gérard, Albert. "John Donne et le Maniérisme: La Structure Scolastique de 'The Extasie,' " in *Approches de l'Art: Mélanges d'Esthétique et de Sciences de l'Art Offerts à Arsène Soreil*. Brussels: La Renaissance du Livre, 1973, pp. 171–183.

483. Greene, Thomas M. "Image and Consciousness in Sceve's 'Delie' " (see entry 605).

484. Hardy, Swana L. "Heinrich von Kleist: Portrait of a Mannerist," *Studies in Romanticism*, 6 (1967): 203–213.

485. Hartmann, Horst. "Barock oder Manierismus?" *Weimarer Beiträge*, 7 (1961): 46–60.

486. Hatzfeld, Helmut. "The Baroque from the Viewpoint of the Literary Historian," *J Aesthetics*, 14 (1955): 156–164.

487. ———. " 'Camões', Manieristische und Tasso's Barocke Gestaltung des Nymphenmotivs," *Portugiesische Forschungen der Gorresgesellschaft*, 3 (1962–1963): 91–109.

488. ———. *Estudios Sobre el Barroco*. Madrid: Gredos, 1964.

489. ———. "Literary Mannerism and Baroque in Spain and France," *Comparative Literature Studies*, 7 (1970): 419–436.

490. ———. "Mannerism is Not Baroque," *L'Esp Créat*, 6 (1966): 225–233.

491. ———. "The Style of Philippe Desportes," *Symposium*, 7 (1953): 262–273.

492. Hocke, Gustav René. *Manierismus in der Literatur*. Hamburg: Rowohlt, 1959.

493. Hoffmann, Jens. "Klassik und Manierismus im Werk Hölderlins," *Hölderlin Jahrbuch*, 11 (1958–1960): 160–189.

494. Hoy, Cyrus. "Jacobean Tragedy and the Mannerist Style," *Shakespeare Survey*, 26 (1973): 49–67.

495. Hubert, J. D. "Un Poème Burlesque au Temps de Malherbe," *L'Esp Créat*, 6 (1966): 282–291.

496. Iser, Wolfgang. "Manieristische Metaphorik in der Englischen Dichtung," *Germanisch Romanische Monatsschrift*, n.s. 10 (1960): 266–287.

497. Jacobus, Lee A. "Richard Crashaw as Mannerist," *Bucknell Review*, 18 (1970): 79–88.

498. Jones, R. O. "Renaissance Butterfly, Mannerist Flea: Tradition and Change in Renaissance Poetry," *Modern Language Notes*, 80 (1965): 166–184.

499. Kawamura, Joichiro. "Donne and Mannerism or Baroque," *Rising Generation*, 119 (1973): 748–755.

500. Kleinschmit von Lengefeld, W. F. "Shakespeare und die Kunstepochen des Barock und des Manierismus," *Shakespeare Jahrbuch*, 82–83 (1946–1947): 88–98.

501. Kunisch, Hermann. "Zum Problem des Manierismus," *Lit Jahr*, n.f. 2 (1961): 173–175.

502. Kytzler, Bernhard. "Manierismus in der Klassischen Antike?," *Coll Germ*, 1 (1967): 2–25.

503. Lange, Klaus Peter. *Theoretiker des Literarischen Manierismus*. Munich: Fink, 1968.

504. Longo, Joseph Anthony. "Shakespeare's 'Dark Period' Reviewed in the Light of Mid-Twentieth Century Criticism," Diss., Rutgers University, *DA*, 24 (1963): 2892.

505. Lüthi, Max. *Shakespeares Dramen*. Berlin: de Gruyter, 1957.

506. McGinn, Donald Joseph and George Howerton, eds. *Literature as a Fine Art*. New York: Gordian, 1967.

507. Mahood, Molly Maureen. *Poetry and Humanism*. New York: Norton, 1970.

508. Martz, Louis L. *The Wit of Love*. Notre Dame: University of Notre Dame Press, 1969.

509. Melchiori, Giorgio. *The Tightrope Walkers: Studies of Mannerism in Modern English Literature*. London: Routledge and Kegan Paul, 1956.

510. Mirollo, James V. "The Mannered and the Mannerist in Late Renaissance Literature" (see entry 605).

511. ———. *Poet of the Marvelous: Giambattista Marino*. New York: Columbia University Press, 1963.

512. Montano, Rocco. *L'Estetica del Rinascimento e del Barocco*. Naples: de Delta, 1962.

513. Morozov, A. "Mannerism and Baroque as Terms of Literary Criticism," *Russkaia Literatura*, no. 3 (1966): 28–43.

514. Mourgues, Odette de. *Metaphysical, Baroque and Précieux Poetry*. Oxford: Clarendon Press, 1953.

515. Mühlher, Robert. "Conrad Ferdinand Meyer und der Manierismus," in *Dichtung der Krise*, ed. by Robert Mühlher. Vienna: Herold, 1951, pp. 147–230.

516. Nash, Ray. "The Making of a Renaissance Book" (see entry 605).

517. Orozco Díaz, Emilio. *Leccion Permanente del Barroco Español*. Madrid: Ateneo, 1952.

518. ———. *Manierismo y Barroco*. Salamanca: Anaya, 1970.

519. Peckham, Morse. *Man's Rage for Chaos*. New York: Chilton, 1965.

520. Pentzell, Raymond J. "The Changeling: Notes on Mannerism in Dramatic Form," *Comparative Drama*, 9 (1975): 3–28.

521. Pieri, Marzio. "Eros e Manierismo nel Marino," *Convivium*, 36 (1968): 453–472.

522. Porqueras Mayo, Alberto. *El Prólogo en la Manierismo y Barroco Españoles*. Madrid: Consejo Superior de Investigaciones Científicas, 1968.

523. Praz, Mario. "Baroque in England," *Modern Philology*, 61 (1964): 169–179.

524. ———. *Secentismo e Marinismo in Inghilterra: John Donne—Richard Crashaw*. Florence: la Voce, 1925.

525. Preminger, Alex, Frank J. Warnke and O. B. Hardison, Jr., eds. *Princeton Encyclopedia of Poetry and Poetics*. enl. ed. Princeton: Princeton University Press, 1974.

526. Priest, Harold Martin. *Renaissance and Baroque Lyrics*. Evanston: Northwestern University Press, 1962.

527. Raimondi, Ezio. "Per la Nozione de Manierismo Letterario: Il Problema del Manierismo nelle Letterature Europee," in *Manierismo, Barocco, Rococò: Concetti e Termini*. Rome: Accademia Nazionale dei Lincei, quaderno 52, 1962, pp. 57–79.

528. ———. *Rinascimento Inquieto.* Palermo: Manfredi, 1965.

529. Raymond, Marcel. "Le Baroque Littéraire Français: État de le Question," *Studi Francesi*, no. 13 (1961): 23–39.

530. ———. "La Pléiade et le Maniérisme," in *Lumières de la Pléiade*, ed. by Pierre Mesnard. Paris: Vrin, 1966, pp. 391–423.

531. ———. *La Poésie Française et le Maniérisme 1546–1610.* Geneva: Droz, 1971.

532. Reichenberger, Kurt. "Das Epische Proömium bei Ronsard, Scève, du Bartas: Stilkritische Betrachtungen zum Problem von Klassischer und Manieristischer Dichtung in der 2. Halfte des 16. Jahrhunderts," *Zeitschrift für Romanische Philologie*, 78 (1962): 1–31.

533. ———. "Der Literarische Manierismus des Ausgehenden 16. und Beginnenden 17. Jahrhunderts in Frankreich," *Romanistisches Jahrbuch*, 13 (1962): 76–86.

534. Rubin, David Lee. "Mannerism and Love: The Sonnets of Abraham de Vermeil," *L'Esp Créat*, 6 (1966): 256–263.

535. Santoli, Vittorio. "Manierismo, Barocco, Rococò: Dichiarazione del Tema," in *Manierismo, Barocco, Rococò: Concetti e Termini*. Rome: Accademia Nazionale dei Lincei, quaderno 52, 1962, pp. 11–23.

536. Sayce, R. A. "Ronsard and Mannerism: The 'Élégie à Janet,' " *L'Esp Créat*, 6 (1966): 234–247.

537. Scaglione, Aldo. "Cinquecento Mannerism and the Uses of Petrarch," *Medieval and Renaissance Studies*, 5 (1971): 122–155.

538. Schetter, Willy. *Untersuchungen zur Epischen Kunst des Statius.* Wiesbaden: Harrassowitz, 1960.

539. Schonauer, Franz. "Manierismus und Modernismus," *Wort und Wahrheit*, 13 (1958): 104–117.

540. Schröder, Gerhart. *Baltasar Gracians 'Criticon': Eine Untersuchung zur Beziehung Zwischen Manierismus und Moralistik.* Munich: Fink, 1966.

541. Scrivano, Riccardo. *Il Manierismo nella Letteratura del Cinquecento.* Padua: Liviana, 1959.

542. Sebba, Gregor. "Baroque and Mannerism: A Retrospect," in *Filología y Crítica Hispánica*, ed. by Alberto Porqueras Mayo and Carlos Rojas. Madrid: Alcalá, 1969, pp. 145–163.

543. Spahr, Blake Lee. "Baroque and Mannerism: Epoch and Style," *Coll Germ*, 1 (1967): 78–100.

544. Stamm, Rudolf. "Englischer Literaturbarock?" in *Die Kunstformen des Barockzeitalters*, ed. by Rudolph Stamm. Bern: Francke, 1955, pp. 383–412.

545. Tetel, Marcel. "Mannerism in the Imagery of Sponde's 'Sonnets de la Mort,' " *Riv Lett Mode Comp*, 21 (1968): 5–12.

546. Thalmann, Marianne. "Der Manierismus in Ludwig Tiecks Literaturkomödien," *Lit Jahr*, n.f. 5 (1964): 345–351.

547. ———. *Romantik und Manierismus*. Stuttgart: Kohlhammer, 1963.

548. Thomas, Lucien Paul. *Étude sur Gongora et le Gongorisme Considérés dans Leurs Rapports avec le Marinisme*. Paris: Champion, 1911.

549. Tuve, Rosemond. "Baroque and Mannerist Milton?" in *Milton Studies in Honor of Harris Francis Fletcher*. Urbana: University of Illinois Press, 1961, pp. 209–225.

550. Ulivi, Ferruccio. *Il Manierismo del Tasso e Altri Studi*. Florence: Olschki, 1966.

551. ———. "Il Manierismo Letterario in Italia," *Convivium*, 35 (1967): 641–654.

552. ———. "Il Manierismo Letterario in Italia," *International Center for the Study of Architecture*, 9 (1967): 399–413.

553. Ungerer, Gustav. "Bartholomew Yong, Mannerist Translator of Spanish Pastoral Romances," *English Studies*, 54 (1973): 439–446.

554. Wadsworth, Philip A. "Malherbe's Youthful Elegy," *L'Esp Créat*, 6 (1966): 264–269.

555. Wanke, Christiane. *Seneca, Lucan, Corneille: Studien zum Manierismus der Romischen Kaiserzeit und der Französischen Klassik*. Heidelberg: Winter, 1964.

556. Warnke, Frank J. *European Metaphysical Poetry*. New Haven: Yale University Press, 1961.

557. ———. "Metaphysical Poetry and the European Context," in *Metaphysical Poetry*, ed. by Malcolm Bradbury and David Palmer. Bloomington: Indiana University Press, 1970, pp. 261–276.

558. Warren, Austin. *Richard Crashaw: A Study in Baroque Sensibility.* Ann Arbor: University of Michigan Press, 1957.

559. Weinberg, Bernard. "Changing Conceptions of the Renaissance: Continental Literature," in *The Renaissance: A Reconsideration of the Theories and Interpretations of the Age,* ed. by Tinsley Helton. Madison: University of Wisconsin Press, 1961, pp. 105–123.

560. Weinrich, Harald. "Fiktionsironie bei Anouilh," *Lit Jahr,* n.f. 2 (1961): 239–253.

561. Weise, Georg. "Manierismo e Letteratura," *Riv Lett Mode Comp,* 13 (1960): 5–52; 19 (1966): 253–278; 21 (1968): 85–127; 22 (1969): 85–112.

562. ————. "Manieristische und Frühbarocke Elemente in den Religiösen Schriften des Pietro Aretino," *Bibliothèque d'Humanisme et Renaissance,* 19 (1957): 170–207.

563. Wellek, René. "The Concept of Baroque in Literary Scholarship," *J Aesthetics,* 5 (1946): 77–109.

564. Wimsatt, W. K. "Laokoön: An Oracle Reconsulted," in *Eighteenth-Century Studies in Honor of Donald F. Hyde,* ed. by W. H. Bond. New York: Grolier, 1970, pp. 347–363.

565. Yuill, William Edward. "Literary Pot-Holing: Some Reflections on Curtius, Hocke and Marianne Thalmann," *German Life and Letters,* 19 (1966): 279–286.

IV. MUSIC

IV. MUSIC

566. Apel, Willi. *Harvard Dictionary of Music.* 2nd ed. Cambridge: Harvard University Press, 1969.

567. Besseler, Heinrich. "Das Renaissanceproblem in der Musik," *Archiv für Musikwissenschaft,* 23 (1966): 1–10.

568. Blom, Eric, ed. *Grove's Dictionary of Music and Musicians.* 5th ed. 10 vols. New York: St. Martin's Press, 1966.

569. Cannon, Beekman C., Alvin H. Johnson and William G. Waite. *The Art of Music: A Short History of Musical Styles and Ideas.* New York: Crowell 1960.

570. Carapezza, Paolo Emilio. "L'Ultimo Oltramontano o Vero l'Antimonteverdi: Un Esempio di 'Musica Reservata' tra Manierismo e Barocco," *Nuova Rivista Musicale Italiana,* 4 (1970): 213–243.

571. Clendenin, William R. *Music History and Theory: A Comprehensive Introduction to Western Music from Primitive Times to the Present.* Garden City: Doubleday, 1965.

572. Federhofer, Hellmut. "Zum Manierismus Problem in der Musik," in *Renaissance Muziek 1400–1600: Donum Natalicum René*

Bernard Lenaerts. Leuven: Katholieke Universiteit te Leuven, 1969, pp. 105–119.

573. Finscher, Ludwig. "Gesualdos Atonalität und das Problem des Musihalischen Manierismus," *Archiv für Musikwissenschaft*, 29 (1972): 1–16.

574. Haar, James. "Classicism and Mannerism in Sixteenth-Century Music," *International Review of Music Aesthetics and Sociology*, 1 (1970): 55–67.

575. Harran, Don. " 'Mannerism' in the Cinquecento Madrigal?" *Mus Qtr*, 55 (1969): 521–544.

576. ———. "Some Early Examples of the Madrigals Cromatico," *Acta Musicologica*, 41 (1969): 240–246.

577. Hucke, Helmut. "Das Problem des Manierismus in der Musik," *Lit Jahr*, n.f. 2 (1961): 219–238.

578. Kaufmann, Henry William. *The Life and Works of Nicola Vicentino 1511–c.1576.* n.p.: American Institute of Musicology, 1966.

579. Kroyer, Theodor. "Zwischen Renaissance und Barock," *Jahrbuch der Musikbibliothek Peters*, 34 (1927): 45–54.

580. Maniates, Maria Rika. "Combinative Techniques in Franco-Flemish Polyphony: A Study of Mannerism in Music from 1450–1530," Diss., Columbia University, *DA*, 26 (1965): 2796.

581. ———. "Mannerist Composition in Franco-Flemish Polyphony," *Mus Qtr*, 52 (1966): 17–36.

582. ———. "Musical Mannerism: Effeteness or Virility?" *Mus Qtr*, 57 (1971): 270–293.

583. Mayer, Harry. "Het Neo-Manierisme," *Mens en Melodie*, 20 (1965): 309–311.

584. Moevs, Robert. "Mannerism and Stylistic Consistency in Stravinsky," *Perspectives of New Music*, 9 (1971): 92–103.

585. Muller, Francis. "Du Maniérisme dans la Musique Contemporaine," *Musique en Jeu*, no. 1 (1970): 8–12.

586. Palisca, Claude V. "A Clarification of 'Musica Reservata' in Jean Taisnier's 'Astrologiae', 1559," *Acta Musicologica*, 31 (1959): 133–161.

587. ———. "Ut Oratoria Musica: The Rhetorical Basis of Musical Mannerism" (see entry 605).

588. Perkins, John MacIvor. "Arthur Berger: The Composer as Mannerist," *Perspectives of New Music*, 5 (1966): 75–92.

589. Reese, Gustave. *Music in the Renaissance*. rev. ed. New York: Norton, 1959.

590. Schrade, Leo. "Von der Maniera der Komposition in der Musik des 16. Jahrhunderts," *Zeitschrift für Musikwissenschaft*, 16 (1934): 3–20.

591. Szweykowski, Zygmunt M. "Czy Istnieje Manieryzm Jako Okres w Historii Muzyki," *Muzyka*, 18 (1973): 32–39.

592. Watkins, Glenn Elson. *Gesualdo: The Man and His Music*. Chapel Hill: University of North Carolina Press, 1973.

593. Wörner, Karl H. *History of Music: A Book for Study and Reference*. 5th ed. trans. Willis Wager. New York: Free Press, 1973.

594. Wolf, Robert Erich. "The Aesthetic Problem of the Renaissance," *Revue Belge de Musicologie*, 9 (1955): 83–102.

595. ————. "Renaissance, Mannerism, Baroque: Three Styles, Three Periods," *Les Colloques de Wégimont*, 4 (1957): 35–80.

596. Wolff, Hellmuth Christian. "Der Manierismus in der Barocken und Romantischen Oper," *Die Musikforschung*, 19 (1966): 261–269.

597. ————. "Manierismus und Musikgeschichte," *Die Musikforschung*, 24 (1971): 245–250.

598. ————. *Die Musik der Alten Niederländer 15. und 16. Jahrhunderts*. Leipzig: Breitkopf-Hartel, 1956.

V. INTERDISCIPLINARY
 PUBLICATIONS

V. INTERDISCIPLINARY PUBLICATIONS

599. Amyx, Clifford. "Style and Method," *Coll Germ*, 1 (1967): 26–37.

600. Artz, Frederick B. *From the Renaissance to Romanticism: Trends in Style in Art, Literature and Music 1300–1830*. Chicago: University of Chicago Press, 1962.

601. Goff, Penrith. "The Limits of Sypher's Theory of Style," *Coll Germ*, 1 (1967): 111–117.

602. Praz, Mario. *Mnemosine: Parallelo tra la Letteratura e le Arti Visive*. Milan: Mondadori, 1971.

603. ———. *Mnemosyne: The Parallel Between Literature and the Visual Arts*. Princeton: Princeton University Press, 1970.

604. ———. *On Neoclassicism*. trans. Angus Davidson. Evanston: Northwestern University Press, 1969.

605. Robinson, Franklin W. and Stephen G. Nichols, Jr., eds. *The Meaning of Mannerism*. Hanover, New Hampshire: University Press of New England, 1972. For contents, see entries 97, 422, 483, 510, 516, 587.

606. Rowland, Daniel B. *Mannerism—Style and Mood: An Anatomy of Four Works in Three Art Forms.* New Haven: Yale University Press, 1964.

607. Sachs, Curt. *The Commonwealth of Art: Style in the Fine Arts, Music and Dance.* New York: Norton, 1946.

608. Stechow, Wolfgang. "The Baroque: A Critical Summary of the Essays by Bukofzer, Hatzfeld and Martin," *J Aesthetics,* 14 (1955): 171–174.

609. Sypher, Wylie. *Four Stages of Renaissance Style: Transformations in Art and Literature 1400–1700.* Garden City: Anchor, 1955.

610. ———. *Rinascimento, Manierismo, Barocco.* trans. Paola Montagner. Padua: Marsilio, 1968.

ADDENDUM

ADDENDUM

611. Agnetti, V. "L'Ideologia del Traditore: Art, Maniera, Manierismo," *Domus*, no. 565 (1976): 55ff.

612. Berg, Darrell Matthew. "The Keyboard Sonatas of C.P.E. Bach: An Expression of the Mannerist Principle," Diss., State University of New York at Buffalo, *DA*, 36 (1975): 4092.

613. Blunt, Anthony F. "Rubens and Architecture," *Burl Mag*, 119 (1977): 609–619.

614. Clifford, T. "Polidoro and English Design," *Connoisseur*, 192 (1976): 282–291.

615. Fowler, Alastair. *Triumphal Forms: Structural Patterns in Elizabethan Poetry*. Cambridge: Cambridge University Press, 1970.

616. Gohlke, M. "Reading Euphues," *Criticism*, 19 (1977): 103–117.

617. Hayward, J. F. *Virtuoso Goldsmiths and the Triumph of Mannerism 1540–1620*. New York: Rizzoli International, 1976.

618. Heideman, J. E. L. "Observations on Girolamo Muziano's Decoration of the Mattei Chapel in S. Maria in Aracoeli in Rome," *Burl Mag*, 119 (1977): 686ff.

619. Kernodle, George. "The Mannerist Stage of Comic Detachment," *Elizabethan Theatre*, 3 (1974): 119–134.

620. Kuretsky, S. D. "Pre-Rembrandtists," *AB*, 58 (1976): 622–624.

621. Lontay, László, et al. *A Manierizmus*. Budapest: Gondolat, 1975.

622. Lowenthal, Anne Walter. "Wtewael's 'Moses' and Dutch Mannerism," *Studies in the History of Art* (1974): 124–141.

623. Maniates, Maria Rika. *Mannerism in Italian Music and Culture, 1530–1630*. Chapel Hill: University of North Carolina Press, 1979.

624. "Ouverture de l'Annee Rubens: Estampes Manieristes," *Art International*, 21 (1977): 56ff.

625. Singleton, Charles Southward, ed. *Art, Science, and History in the Renaissance*. Baltimore: Johns Hopkins Press, 1967.

626. Spear, R. E. "Johann Liss Reconsidered," *AB*, 58 (1976): 582–593.

627. Vervaet, J. "Mannerism and the Italian Influence in Sixteenth-Century Antwerp," *Apollo*, n.s. 105 (1977): 168–175.

628. Viatte, F. "A Propos d'un Nouveau Dessin de Morazzone," *La Revue du Louvre et des Musees de France*, 27, no. 3 (1977): 164–169.

629. Vroonland, Jewell Kay. "Mannerism and Shakespeare's 'Problem Plays': An Argument for Revaluation," Diss., Kansas State University, *DA*, 30 (1969): 2502.

630. Vyverberg, Henry. *The Living Tradition: Art, Music, and Ideas in the Western World*. New York: Harcourt, Brace, Jovanovich, 1978.

631. Wagner, David Leslie. "Mannerism as a Concept of Historical Periodization," Diss., University of Michigan, *CDI*, 37 (1960): 698.

COMPILERS

COMPILERS

Richard Studing

Richard Studing teaches Comparative Arts in the Department of Humanities at Wayne State University where he is an Assistant Professor of Humanities. He received his B.A. and Ph.D. from Wayne State and has taught there since 1967. His main interests in teaching and research are Shakespeare and Renaissance Studies. He has published essays on Shakespeare related to art and on Shakespearean subjects and themes as depicted in art. Also, Professor Studing has written on Yeats and has done bibliographic studies on American and Canadian authors. In 1978, he was research consultant and co-organizer of the art exhibition, *Fantastic Shakespeare*, held at the Gallery/Stratford (Ontario) and was co-author of the catalogue for the exhibition. He is currently at work on a long-range project entitled, "Shakespeare in American Art."

Elizabeth Kruz

Pursuing her primary interest in Renaissance Studies, Elizabeth Kruz received B.A. and M.A. degrees in Humanities from Wayne State University where she was a Library Assistant. She continues her participation in the Humanities as a part-time instructor for Wayne County Community College while holding a position as a Technical Library Assistant for the Burroughs Corporation.